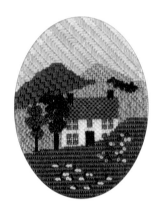

Needlepoint
Stitches

To my grandchildren Hannah,
Lawrence, Fergus and Max.

Needlepoint
Stitches

Susan Higginson

SEARCH PRESS

First published in Great Britain 2007

Search Press Limited
Wellwood, North Farm Road,
Tunbridge Wells, Kent TN2 3DR

Text copyright © Susan Higginson 2007
Needlework designs © Susan Higginson 2007

Photographs by Charlotte de la Bédoyère, Search Press Studios
Charts by Susan Higginson
Photographs and design copyright © Search Press Ltd 2007

ISBN-10: 1-84448-096-8
ISBN-13: 978-1-84448-096-8

Suppliers
If you have difficulty in obtaining any of the materials and
equipment mentioned in this book, please visit the Search Press
website for details of suppliers: www.searchpress.com

Alternatively, you can write to the Publishers at the address above
for a current list of stockists, which includes firms who operate a
mail-order service.

Acknowledgements

*Thanks to my husband Derek for his help and support
throughout this project, and to all at Search Press for
their friendly professionalism.*

Publishers note
All the step-by-step photographs in this book feature the
author Susan Higginson, demonstrating needlepoint stitches.
No models have been used.

Contents

Introduction

With more than three hundred different stitches, needlepoint (also known as tapestry or canvas work) is versatile, decorative and fascinating. I could not include the whole range of stitches here, so I have chosen the ones that are the most liked and used by my students. They are all simple, but as with any skill there is 'insider' knowledge that can only be gleaned from someone who has been practising the technique for a long time.

Many of the stitches featured are bold and chunky and all can be used in a variety of different ways. A great advantage is that the same stitches can be worked on fine canvas just as easily as on a piece of wide-mesh rug canvas. Only the threads used for each are different.

It is very satisfying to work from your own ideas, so I have included plenty of information and hints on designing your own projects on pages 18–19. When these pieces of work are finished, you have the gratification of knowing that they are your creations from beginning to end.

The aim of this book is to make you feel that I am sitting by your side as you work, guiding you through every stage of each stitch and answering your questions before you ask them. The detailed photographs of actual stitching, the clear stitch diagrams and the many tips will help you to produce a piece of needlepoint that will give you lasting pleasure. I have included two projects on pages 72–79. The first is a brightly coloured spectacles case and the second is a landscape which can be framed or made up into a cushion. You can use the colours I have suggested for each, or choose your own.

I hope you get as much pleasure out of needlepoint as I have done over the years.

Susan Higginson

This is a sampler of twenty different stitches. All are described in the Stitches chapter (pages 20–71).

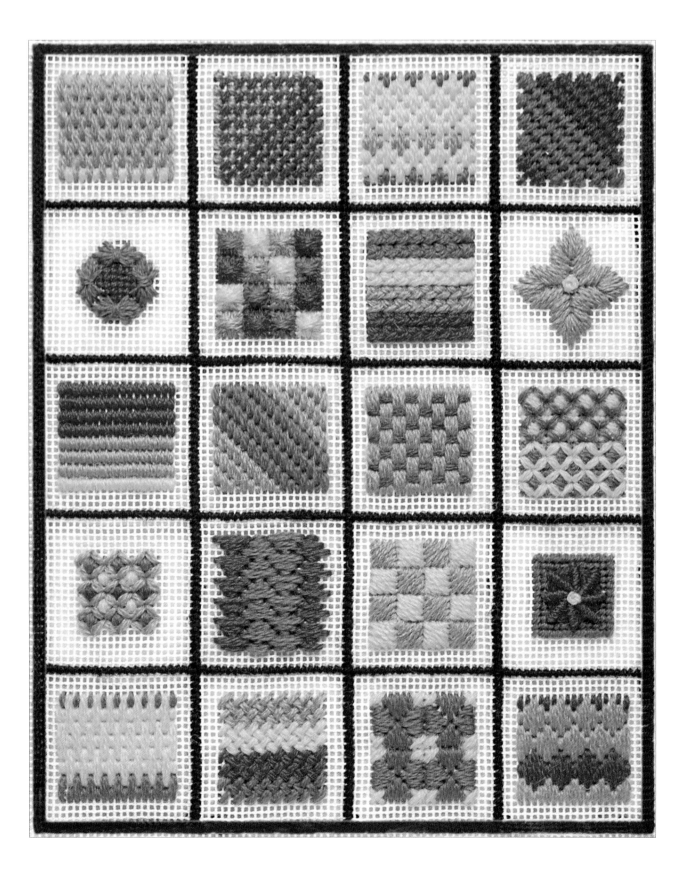

Materials

Canvas

Needlepoint is worked on canvas that can be purchased in a large variety of different types and mesh sizes. For a beginner I would certainly recommend an interlock canvas, which is manufactured in such a way that the canvas threads are 'locked' in place. This means that the squares stay in shape and the edges do not fray, two characteristics that are very useful.

If you find that your white interlock canvas is rather bright, or that the canvas shows through when working with straight stitches, you can colour it before use with dryish acrylic paints or coloured pencils.

If you are a beginner you should work on a canvas with a large enough mesh for you to see the holes clearly. The two sizes of mesh I would recommend are ten threads per inch (10s) if you have any difficulties in seeing detail, or thirteen threads per inch (13s) if you can see really well. The advantage of working with the smaller mesh size is that the finished stitches tend to look neater, and if you prefer this, you can always use a magnifying lens to help you to see the canvas clearly.

Shown here are rolls of canvas, with ten threads per inch (left) and thirteen threads per inch (right).

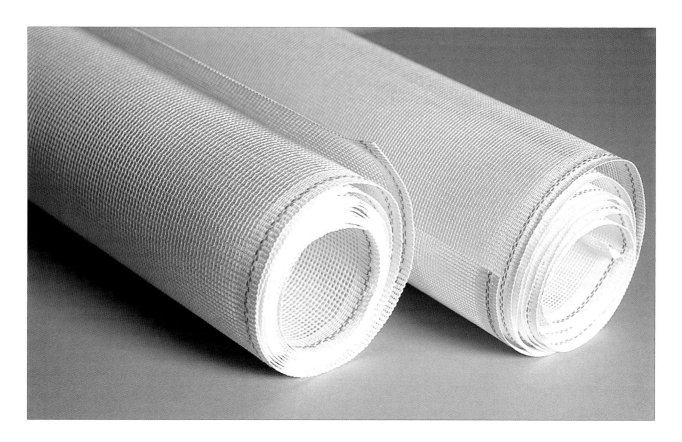

Threads

Needlepoint on canvas of the mesh sizes we are considering is usually worked in wool. The choice is usually between crewel wool, tapestry wool and Persian yarn. I have tried many different types of wool over the years, but have only consistently liked the two-ply crewel wools.

These are spun without a marked twist and give a very smooth and lustrous finish. The wool is fine and you use a different number of threads in the needle depending on the stitch being used and the mesh of your canvas. This means that you can mix colours in your needle for special effects which result in more subtle and interesting work.

Persian yarn is a high quality product which has three two-ply strands with a marked twist loosely plied together. You use the number of strands you need for your canvas mesh size. This wool is suitable if you do not want to do colour mixing in the needle as the strands do not merge together well. Tapestry wools tend to be rather furry if handled a great deal and are usually used on canvas of ten threads to the inch.

Other types of yarn may be used, such as embroidery floss on fine canvas and metallic threads for special effects.

Tip

When using size 18 needles, use four strands of crewel wool. If using size 20 needles, use three strands.

Needles

Blunt-ended tapestry needles must always be used for needlepoint. If sharp-ended needles are used it is very difficult to avoid pushing the point into the canvas instead of the hole.

If using a size 10 mesh canvas you will need size 18 needles. If using a size 13 mesh canvas you will need size 20 needles.

This owl is magnetic, so he is very useful to have handy to store needles safely.

Embellishments

You may wish to add extra embellishments to some of your pieces of work, such as the small beads used on the shell design on page 19. Sequins and metallic threads are also useful and attractive. There are no limits to what you can use and your choices add to the uniqueness of your work.

Frames

Many different sizes and types of frames are available, but probably to begin with you will find it easiest to hold your work in your hand. Start off with a fairly small piece of canvas – smaller than the page size of this book. This means you can concentrate on the stitching rather than on controlling the canvas.

When buying a frame, make sure that you choose one that is wide enough for your piece of work, and has the possibility of rolling the length of the canvas round the top and bottom bars. These can be tightened to create a taut working area.

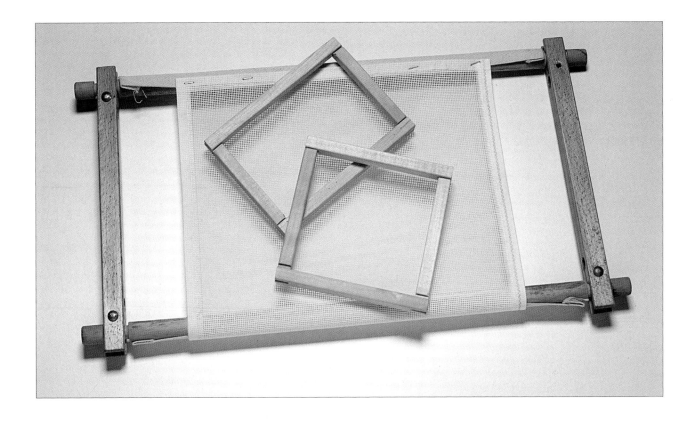

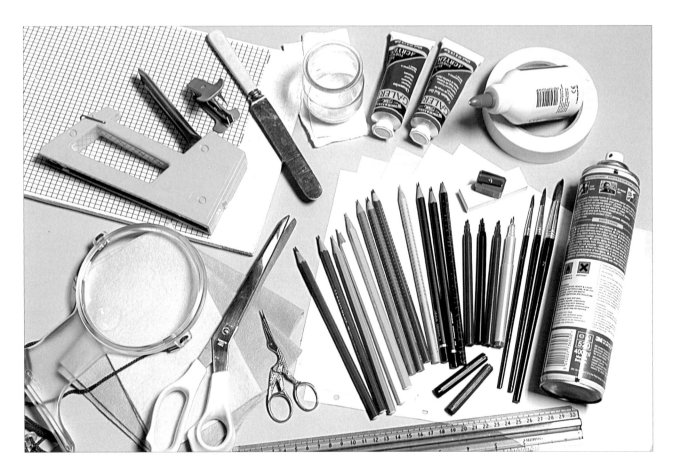

Other items

For general tasks, various types of **magnifying lens** are available, both free-standing and made to be worn around the neck. These allow you to see the stitches in more detail and prevent you from straining your eyes. You will need a large pair of **scissors** for cutting canvas and small **embroidery scissors** for snipping wool. **Masking tape** is used for binding the canvas prior to use in order to prevent the wool catching on the canvas edge during stitching.

When designing a piece, you will need a **pencil, plain paper, tracing paper, graph paper, felt tip markers, ruler, eraser** and a **pencil sharpener**. Use a relatively hard pencil, such as an HB, or an H. This will ensure that you only get a faint mark on your canvas, and the pencil will not leave any residue of graphite which could mark your wool in the stitching process.

Thin **felt** is used for lining spectacles cases and needle cases. **PVA glue** is a white, easy-spreading emulsion glue much used in craft projects. It dries quickly to a waterproof, translucent film. It can be washed off hands, clothing and spreaders with water immediately after use.

For the finishing process you will need a **staple gun** and **staple remover**, **wallpaper paste** and a round-ended **table knife** to spread it on your work, a piece of **hardboard covered with graph paper** and some small pieces of **thin towelling**. Finally, **fabric protector** is very useful to make sure your needlepoint stays looking its best.

Tip

Coloured pencils or **acrylic paints** may be used to colour the canvas behind straight stitches if they are not covering the canvas properly. These coloured pencils and paints should match the wool to be used as far as possible.

Another way round this problem is to put another thread of wool in the needle.

11

Techniques

You only need to learn a few simple techniques in order to produce a piece of needlepoint with a very professional finish, so it is worthwhile spending time on perfecting them.

Working with crewel wool

When starting to use a hank of crewel wool, cut it twice so that you have two identical half hanks. Take the wool off the half hank carefully, either by selecting the number of threads you need at the centre of the length and pulling gently towards the ends, or by pulling the threads one at a time from one end.

 Whatever form your supply of crewel wool takes, remember that the wool has a definite direction of twist, so several pieces should all be put together in the same direction as they are taken off the skein or hank.

 A thread length of about 50cm (20in) is ideal for mixed stitches. If you are working with a hank of crewel wool and making large stitches, it is usual to work with the length of the half hank. This may be up to 75cm (30in).

Preparing the canvas

Canvas, like any material, has selvedges along each side, and you should always keep the selvedge at the side of the work when cutting a piece to work on.

 The size of the canvas on which you work will eventually come down to personal preference, but to start with leave about 4cm (1½in) of bare canvas around your design. This gives you something to hold on to when you are stretching the canvas during the finishing process. Later you may decide you prefer to have more or less edging with which to work. I always edge the canvas with masking tape to prevent the wool from catching on the rough edges.

Tip

If you are working on the canvas held in your hand, cut the corners off with a pair of scissors after step 3.

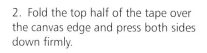

1. Lay the tape down on a table sticky side up and place one canvas edge along the bottom half. Cut the tape to length.

2. Fold the top half of the tape over the canvas edge and press both sides down firmly.

3. Do the same on the remaining three sides of the canvas.

Transferring a design

When you have drawn out a design, such as a picture, it is easy to transfer this on to your prepared piece of canvas, ready for stitching.

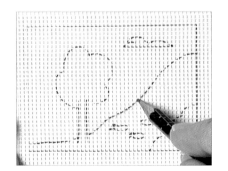

1. Draw your design on paper, and go over it with a dark felt tip pen. Lay your prepared canvas over the design and trace it with a pencil.

2. The faint outline will help you when working your design.

Tip

Many designs need no more than a basic outline to be marked on to the canvas before stitching. You need only decide the approximate size of your finished project so that you can place the design correctly on the canvas, having allowed 4cm (1½in) all around for stretching and finishing.

This design was placed on the canvas by counting the number of threads the blocks covered vertically and horizontally. The finished piece can be seen on page 5.

Framing up

Framing your canvas keeps it taut and easy to work on, and also keeps it cleaner than working while holding the canvas in your hand. Most wooden frames have pieces of webbing attached to the top and bottom bars. You can sew your canvas to this webbing or you can staple the prepared canvas directly on to the bars with a staple gun.

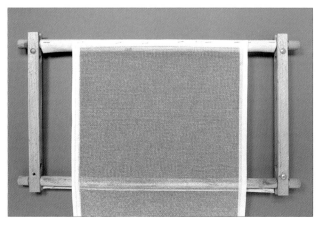

1. Staple your prepared piece of canvas to the top bar.

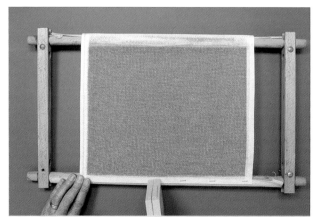

2. Turn the top bar until the canvas reaches the bottom bar, then secure with staples. Finally, rotate the top bar until the area in which you will work is taut, and tighten the wing nuts on the frame.

Threading the needle

To ensure that your work covers the fabric evenly, use four threads with a size 18 needle, and three threads with a size 20. The movement of the wool through the canvas as you sew gradually wears the thread until it is quite thin. Start a new thread if the work looks uneven.

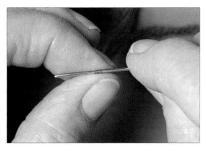

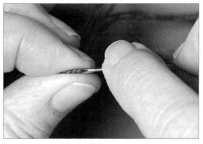

1. Fold several inches of wool over the eye of the needle and hold it firmly. Keep the threads side by side on the needle, rather than held in a bunch.

2. Pull the needle out, leaving a very small fold of wool showing. Push the eye of the needle down into this fold, letting the wool move into the hole as your finger and thumb part.

Tip

Move the needle along the wool occasionally so that you do not wear a weak point in the thread.

Starting and finishing a length of thread

Starting a thread

There are several different ways of starting the stitching. Here I demonstrate a quick and easy way for beginners to start stitching on an empty canvas.

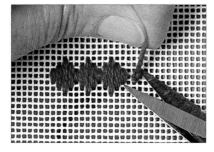

1. With a knot on the end of your thread, push the needle and thread through the canvas so that the knot rests on the front of the canvas 2.5cm (1in) from your starting point.

2. Work your stitches towards the knot over the wool lying at the back of the work. When you reach the knot, cut it off flush with the canvas. Never leave a working knot anywhere in your stitchery.

Tip

While working, you may find that your tracing wears off the canvas. You can always refresh your lines by replacing the canvas over your original design.

Finishing a thread

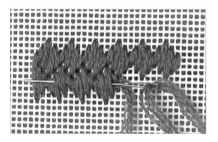

1. On the back of the work, push the needle and thread through about 2cm (¾in) of the worked stitches.

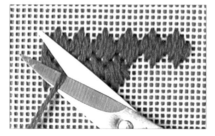

2. Cut off flush with the stitchery of the worked area.

Tip

Never leave any loose ends of threads on the back of the work. They spoil the look of your finished work, and can easily be pulled through to the front when making another stitch.

Stitching

You must aim for an even tension when working the stitches, otherwise the finished work will not look professional and smart.

If you use the stab stitch method, this even tension will be easier to achieve. Do not put the needle through two holes at the same time and pull the thread through as in running stitch. This creates a great deal of wear on the wool.

Stab stitch

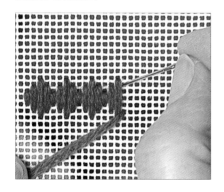

1. Hold the thread taut, and take the needle and all the thread straight through the canvas. Pull it through gently but firmly until it is tight.

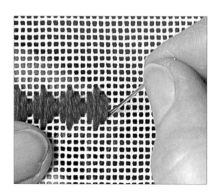

2. Bring the needle back up through the work. Maintain an even tension and avoid tangled wool by holding the wool taut on the back and front of the work as you pull the wool through the hole.

Tip

If it is possible when making a stitch you should always choose to pull your needle up through a hole which has no other stitch in it.

When you pull the needle through from the back of the work you can easily pull through any loose ends of wool which may be dangling from the back. Similarly, when you push your needle through a hole which has a stitch in it already the action pushes through any hairy bits and can firm up any loose stitches.

Compensation stitches

When you are working using large stitches there are always spaces where a whole stitch will not fit. Compensation stitches are those parts of the main stitch with which you fill these spaces.

Do not attempt to start a row with compensation stitches as it is sometimes very difficult to work out what they will be. Start by placing a whole stitch in its correct place in relation to the previous row. Go back afterwards to fill in the compensation stitch spaces with whatever parts of the main stitch will fit in.

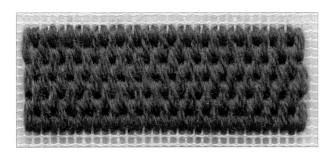

Easy compensation stitches in brick stitch, a simple straight stitch. The compensation stitches are shown in red.

Compensation stitches in a diagonal stitch – Milanese. The compensation stitches are shown in green.

Finishing

When you have finished all the stitchery you must stretch the work on a board to make sure it is exactly the correct size and shape, and that all the stitches look their best. Some of the stitches may well have pulled the canvas out of shape, but a good stretching will put matters right.

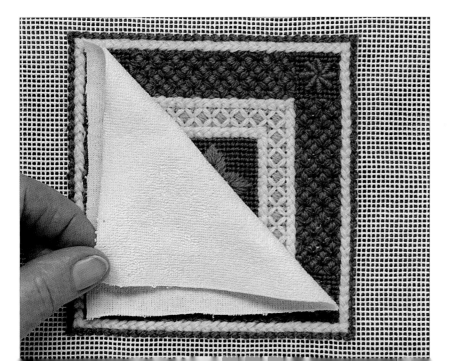

You will need
Piece of board marked with 0.5cm (¼in) squares and covered with transparent plastic.
Thin towelling
Staple gun
Prepared wallpaper paste
Round-ended kitchen knife
Clean, damp cloth

1. If you have used three-dimensional stitches, place a thin piece of towelling between the stitched area and the board so that your stitches will not be flattened.

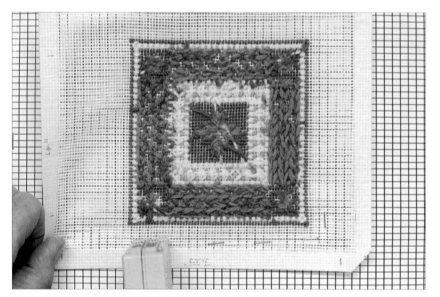

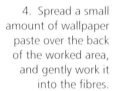

2. Lay the canvas face down on the board, with the towelling behind to protect your stitches. Using a damp cloth, slightly dampen the back of the stitched area. Line up one line of holes of the canvas about 1cm (½in) away from the stitched area with a line showing through from the marked board and staple down firmly while pulling the canvas taut.

3. Work round the other three sides in similar fashion making sure the canvas is taut and in its original shape.

4. Spread a small amount of wallpaper paste over the back of the worked area, and gently work it into the fibres.

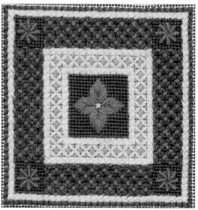

5. Leave to dry for at least twenty-four hours. Remove the staples from the canvas, and admire your work, which will now look fantastic.

Tip

Unless they are to be framed, I always spray my pieces of work with fabric protector, which protects them from dirt and spills. Test out the product on a spare piece of stitching before applying it to your precious piece of work.

Design

Designing your own pieces of needlepoint is very satisfying and once you have started working in this way you will realise that it is not difficult.

Ideas which can be used in designing your own pieces of needlepoint are all around you – you just need to recognise them.

It is a good idea to make a collection of your favourite postcards, swatches of material, photographs, pieces of wrapping paper, advertisements, shells and other objects or designs which appeal to you. Whenever you want to begin a new project you will then have lots of possible starting points.

The design you make from your initial reference will almost certainly be nothing like the original, but these sources will have sparked off your imagination.

There are many decisions to be made and stages to go through when designing, and you may find the process spreads over a couple of days as the various ideas and changes come to mind. What colours will I use in my design? Will I use many stitches, just a few, or perhaps even just one? How will I translate my initial inspiration into what will work best in needlepoint?

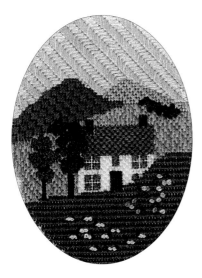

The design for this simple cottage scene was first outlined in my sketchbook.

Guidelines to help you with design

• When designing projects using any of the larger stitches found in this book, you must think big and make sure the areas allotted for each stitch are large enough to show them off to advantage. You will notice that the stitches, apart from the motif stitches, only look their best when several rows have been worked.

• Do not attempt to include too much detail. You will find this is difficult to show using these chunky stitches.

• You do not need to be an artist to design for needlepoint. The mesh of the canvas keeps everything neat and tidy, and the character and beauty of a needlepoint design lies to a great extent in the stitches themselves and in the colours in which you choose to work them. Most projects can be designed using no more than a pencil and paper.

• Choosing which stitches to use can be difficult at first. Do not feel you have to decide in advance every colour of wool and every stitch to be used in the project. You will find that as you put one block of stitches in, you know intuitively what would look good next to it, both in colour and type of stitch.

• It is usually a good idea to put stitches which run in different directions next to each other to give contrast, and to have a good mix of flat and three dimensional stitches.

• In pictorial work try to choose stitches which emphasise whatever feature is being represented. For example, try a diagonal stitch for the sky to suggest shafts of light striking the earth, a straight stitch for a fence and a brick stitch for roof tiles.

Designing the Shell Square

This Shell Square is a good example of how you can use a simple object as the basis for a design.

I worked the design in six-strand mercerised embroidery cottons, which work well on fine canvas, and have the advantage of being high in lustre.

The stitches I chose had to be fairly small and pale to prevent their overpowering the delicacy of the subject matter. The background called for a good contrasting colour with a connection to the sea, perhaps a wavy pattern, so I used arrowhead stitch in a dark marine blue. A border of long-legged cross variation stitch finished off the square.

1. I took an actual shell for the inspiration of this design.

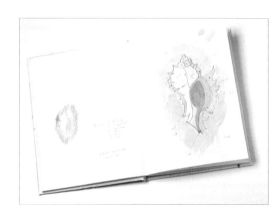

2. After sketching the shell on to paper, I added some watercolours. This was a small design with a lot of detail so I chose a fine gauge 18s interlock canvas, and used a size 22 tapestry needle.

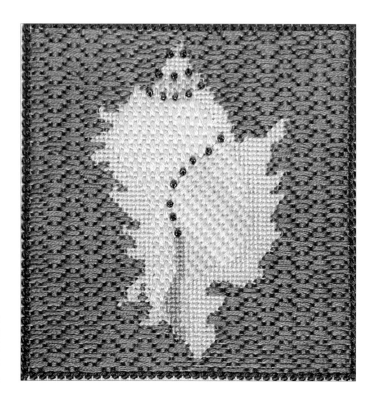

3. I transferred the outline of the shell to the canvas using the tracing method described on page 13, and kept the actual shell and the painting to hand to refer to as I stitched.

Stitches

When working from the stitch diagrams, work in numerical order, and always bring your needle up through the canvas at odd numbers and down into the canvas at even numbers.

Some stitches need to be worked in stages. Where this is the case, the darker parts of the diagram need to be worked first, followed by the lighter parts. The alphabetical sequences, where present, should be followed after the numerical sequence is completed.

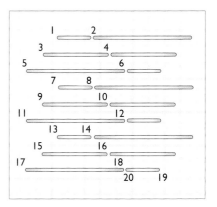

Straight stitches

Arrowhead stitch

Arrowhead stitch is easy, and covers the canvas quickly when working a large background area. You can use it for the sky in a formal landscape, or for part of a purely patterned piece of work. It is a good idea to add an extra strand of crewel wool if the canvas shows through the straight stitches. Being a straight stitch, arrowhead stitch does not distort the canvas.

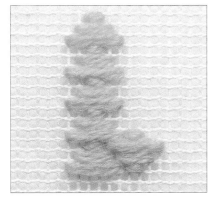

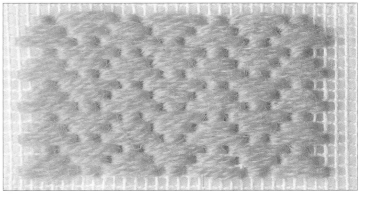

1. Work stitches over 2, 4 and 6 threads of the canvas and then repeat in a line down the canvas as shown.

2. Work the second and following rows up and down, working the longest stitch up against the shortest stitch of the previous row and so on, leaving no gaps.

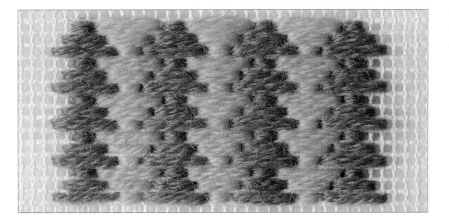

You can achieve a striped pattern by working alternate rows in a different colour or colours.

Back stitch

Back stitch, though not an interesting stitch itself, is nevertheless very useful as it can be used to outline any shape you may want to fill in with other stitches. It is therefore possible to make smooth edges to areas which without the back stitch outline would appear to have very squared-off edges. Back stitch can also be used to fill in a narrow gap left between rows of other stitches.

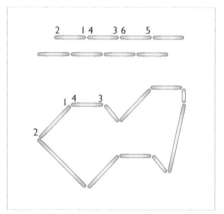

1. You can see from the numbering on the charts that back stitch is indeed worked backwards following any line you choose to make. The smaller the stitches, the more tightly the line can be curved. You can make the stitches longer on a straight line.

When filling in a back stitch shape make sure you do not split the wool forming the edges. Try to tuck the stitches under the back stitch edge.

Brick stitch

Brick stitch and its variations are some of the most used needlepoint stitches. It has a very neat appearance when you have worked several rows and as with all straight stitches you can use it either vertically or horizontally.

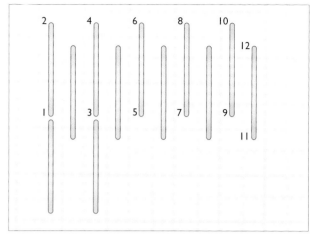

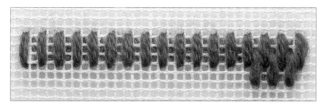

1. For the first row, work a series of vertical stitches over four canvas threads, leaving one hole (two threads) between each stitch. For the second row, drop down two threads and work the second row from right to left in exactly the same way, making the stitches into the gaps between the stitches of the first row.

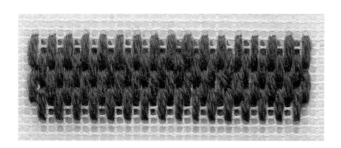

2. The effectiveness of the stitch starts to appear after a few rows. Work the rows backwards and forwards as required.

Single brick stitch: This is worked in exactly the same way as brick stitch except that all the individual stitches are worked over two canvas threads instead of four. You can use this stitch as an alternative to half cross stitch (page 60) in a background.

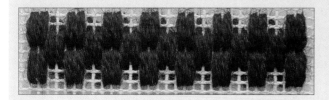

Double brick stitch: This is worked in the same way as brick stitch except that a pair of upright stitches over four canvas threads is worked each time instead of just one. Be aware that when working double brick stitch you must leave two holes between each pair of threads to leave room for the next row.

Chevron stitch

Chevron stitch, like twill stitch (page 31), is a straight stitch which has the appearance of a diagonal stitch. As straight stitches do not pull the canvas out of shape, these stitches are very useful for subjects such as skies or hillsides in a landscape, or as a contrast to upright stitches in formal work.

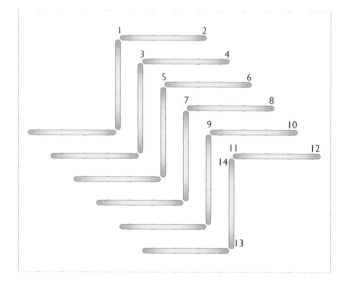

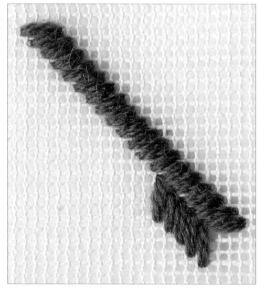

Tip

Straight stitches do not cover the canvas as well as stitches worked diagonally, so be prepared to add an extra strand of wool in the needle if the background shows through.

1. Work a row of horizontal stitches over four threads diagonally down the canvas. You can work down to the left or the right, whichever suits your needs. When working up from the bottom make a line of vertical stitches over four threads into the bottom of the stitches of the first row.

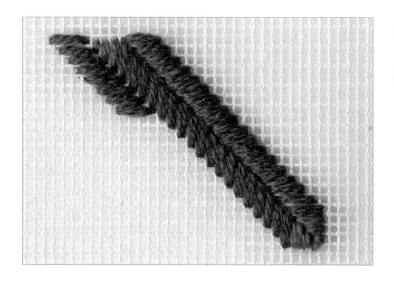

2. To make a straight edge on any side of the work, compensation stitches must be worked. These are shown in the alternate colour. They are always shorter than a whole stitch.

Diamond straight stitch

This is a very neat formal stitch which looks its best if you work it in two contrasting colours. You could use it in a border with a motif stitch in the corners, or as a complete covering stitch for a rectangular item such as a chair seat or stool top.

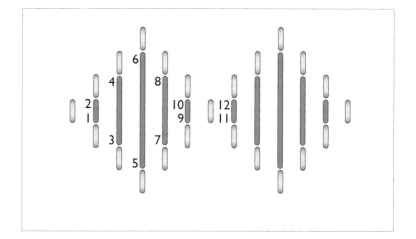

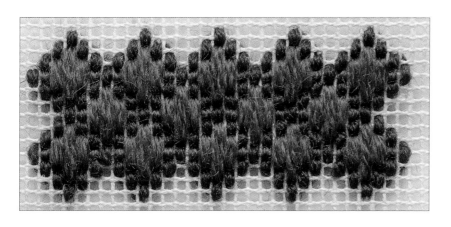

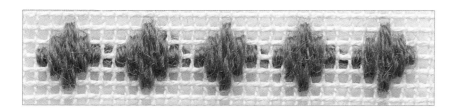

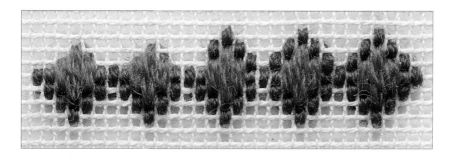

1. Work a line of diamond motifs over 1, 3, 5, 3 and 1 horizontal canvas threads in the main colour, leaving a gap of one hole between motifs.

2. With the second colour work small stitches over one canvas thread all round each motif. I find it best to start at the left-hand end and work the stitches first round the bottom of all the motifs, and then turn the work upside down and work back along the top. This way you work into the full holes and come out in the empty holes.

3. As each row of motifs is worked, put in the small contrasting stitches round them as required.

Hungarian stitch

Hungarian stitch is very easy to work. You need to make sure that you leave a gap between each motif of three upright stitches to accommodate the longest stitch of the following row.

The finished result is very smooth and neat and you will find it makes an effective stitch in landscapes as well as on formal patterned designs.

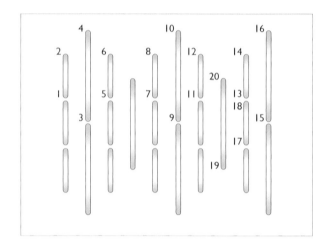

1. Work a line of motifs over 2, 4 and 2 horizontal canvas threads, leaving a gap of one hole between each motif.

2. Work the second row back from right to left so that the longest stitch of each motif fits into a gap on the preceding row. You will notice that all the short stitches come underneath each other, as do the long stitches.

You can work rows in different colours to give a striped effect, either in contrasting colours or shades of the same colour.

Hungarian diamonds stitch

Hungarian diamonds stitch is one of my favourite stitches and I use it in most of my pieces of work. It always looks neat and catches the light well. It is one of the easiest stitches to use as you do not have to remember to leave spaces for stitches of the next row. Being a straight stitch it can be worked either vertically or horizontally and single diamonds may be used on their own as a motif.

1. Starting at the left, work upright stitches next to each other over 2, 4, 6 and 4 canvas threads and then repeat along the row.

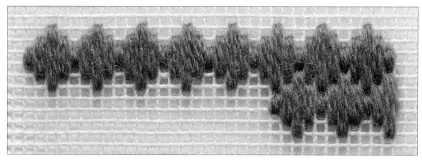

2. Work the second row from right to left into the gaps underneath the first row, placing the longest stitch under the shortest and the shortest under the longest, leaving no gaps.

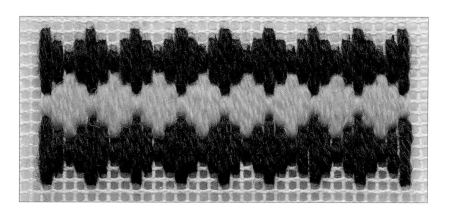

You can make a striped effect if required.

Hungarian grounding stitch

This is a composite stitch in which a small motif is placed in between two rows of a simple Florentine stitch (page 34) over four threads with a one-thread step. It is usually worked in two colours but may be worked all in one colour if required.

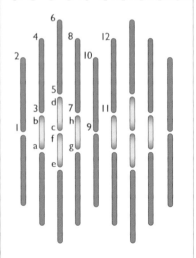

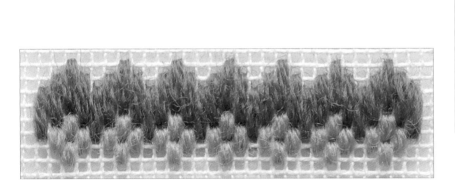

1. Work a line of the Florentine stitch by following the numbered sequence, then go back to the beginning of the row and work the motif below by following the alphabetical sequence. Leave one hole between each motif.

Tip

If you have plenty of the first colour of wool left in your needle you can put it on one side while you work the motifs. The best way to do this is to bring the needle and wool out to the front of the work well away from where you are working while you use your second colour. By doing this you are unlikely to get it tangled in the thread which you are using.

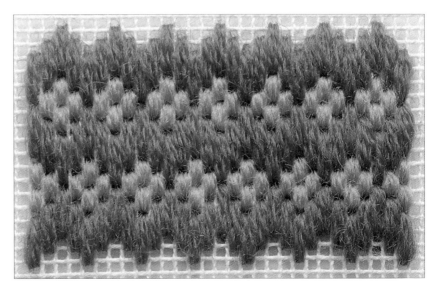

2. Work the next row of Florentine stitch back from right to left, before inserting the next row of motifs and so on.

Long stitch

This is a bold patterned stitch which is very easy to work. It may be worked over different numbers of threads, but usually covers six horizontal threads in total. If you want the top of one of the motifs to be in the middle of a row you are working, it is best to start in the middle and work out from there to the edges. You may need an extra thread of wool in your needle for this stitch to cover the canvas well.

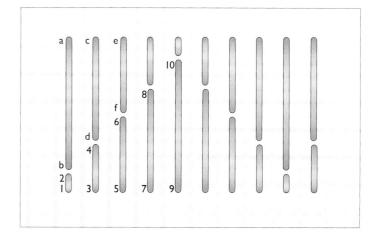

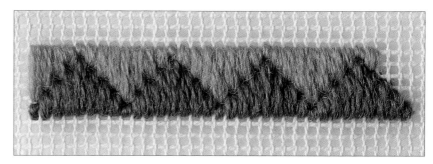

1. The bottom half of the stitch is worked first by following the numerical sequence on the diagram, over 1, 2, 3, 4, 5, 4, 3 and 2 horizontal canvas threads. Repeat this sequence for the length of your row.

Tip

Do not forget to use stab stitch all the time. If you attempt to save wool by cutting across the top of your stitches they will not lie straight and the smooth effect will be lost.

Tip

A single colour may be used for this stitch. In this case you should choose a pale colour as the shape of the stitch will show up better. This is because shadows are cast which do not show up if the wool is dark.

2. Start from the left again. From one thread above the longest stitch, work straight stitches down into the holes already filled. Make sure you leave room for the stitch over one thread to fit in above the longest stitch of the first part. The stitches this time will be over 5, 4, 3, 2, 1, 2, 3 and 4 horizontal canvas threads, and will follow the alphabetical sequence on the diagram.

Parisian stitch

Parisian stitch is a straight stitch which is usually worked over six and two threads of canvas. However it may also be worked half size, over three threads and one thread of canvas. Both are very handsome, easily worked stitches and may be worked either vertically or horizontally.

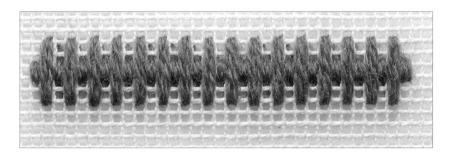

1. Work a line of stitches from left to right over six and two horizontal canvas threads with no gaps.

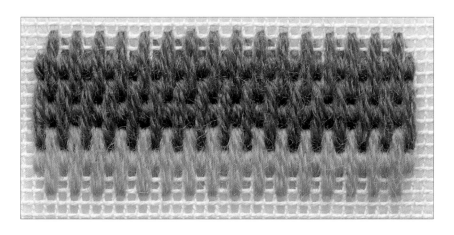

2. Work back from right to left, bottom to top, placing a long stitch under each of the short stitches of the first row, and a short stitch under each of the long stitches.

Single trammed gobelin stitch

Single trammed gobelin has the marked ribbed effect so typical of the genuine gobelin tapestries and as such is most useful for making a contrast to any other stitch. It can form a raised edging to a patterned piece or form a ploughed field on a needlepoint picture. This is an easily worked and very versatile stitch which I use a great deal.

1. Anchor the end of the thread firmly before you lay down the first thread (the tramming thread) over which you will work the rest of the stitch. Bring the needle and all of the thread to the front of the work at the start of the row and then take the needle and all the thread through to the back of the work at the end of the row. Make sure you do not buckle the canvas. Bring the needle to the front of the work one thread below where you went in and stitch over the tramming thread into the hole immediately above the tramming thread. Work back along the whole tramming thread in this manner.

Tip

All rows must be worked in the same direction otherwise the stitches will not lie parallel.

2. Lay down the next tramming thread in the same manner two threads below the first one and then work back along it in the same way. The vertical threads will be worked into the bottom of the vertical stitches of the first row, leaving no gaps in the work. Once you have worked a few rows, cut off the knot.

Tip

If there is already stitchery on the canvas to anchor your first tramming thread, there is no need for the knot.

You can produce dramatic stripes with this stitch.

Twill and double twill stitch

Twill is a very useful stitch in that it gives the appearance of being a diagonal stitch but is in fact a straight stitch and thus does not pull the canvas out of shape when being worked. It is very versatile as it can be worked over different numbers of horizontal canvas threads to suit the needs of the current project. For double twill the stitch is worked over a different number of horizontal threads on alternate rows, to achieve a more varied effect. Shading can be achieved in this stitch by changing the combination of different shades of wool in the needle to suit requirements. This is effective if you are working a sky, for instance.

1. Work a diagonal line of vertical stitches down the canvas over three horizontal canvas threads, stepping down one thread with each successive stitch.

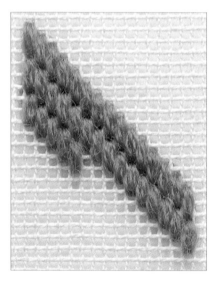

2. The second row is worked by dropping down three threads and working back up the row into the base of the first row stitches. The third row is worked down as the first.

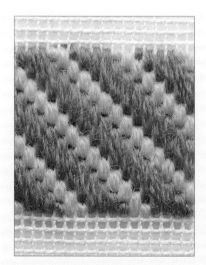

Double twill stitch: This is worked in the same way as twill stitch, except that alternate rows are worked over a different number of threads. In this sample I have chosen to do rows over four threads alternating with different coloured rows over two threads, but there is no hard and fast rule as to what may be done.

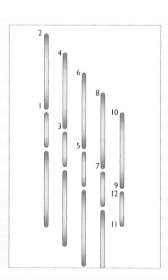

Tip
You can use two colours in both twill and double twill if required.

Weaving stitch

This is an unusual stitch in that part of the stitch has to be worked into holes that are masked behind another part of the stitch. Groups of three straight stitches are placed at right angles to each other, the end result being that they appear to be interwoven as in weaving. You have to be careful not to split the threads of the stitches already in place when working into the masked holes.

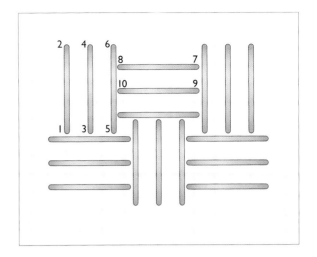

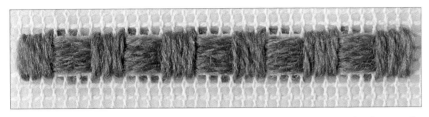

1. Work three upright stitches over four horizontal canvas threads. Take the needle behind the canvas and come out to the front again four canvas threads to the right, so that you can work the three stitches at right angles into the three holes available (note that one of these four canvas threads may be slightly masked by the stitches already in place). You will have to angle your needle to get into the holes without catching the threads masking them.

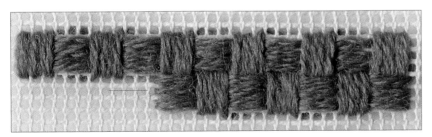

2. Work the second row back from right to left in the same fashion, placing the vertical stitches under the horizontal ones of the first row so that the weaving effect is continued.

A chequerboard effect can be produced by working with two colours. It is necessary in this case to use two needles threaded with the different colours, as it is not easy to place the second colour if you do all the horizontal or vertical stitches first.

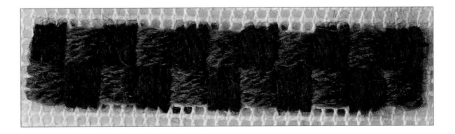

Willow stitch

This stitch, like weaving stitch, gives the appearance of an interwoven fabric, but is achieved in an entirely different way as the second colour (or the same colour if you prefer) is not added until the first colour stitches are all in place.

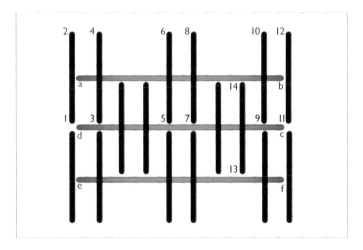

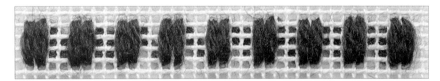

1. Work a line of double brick stitch (see page 22 for instructions).

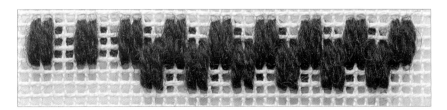

2. Work the second row back from right to left.

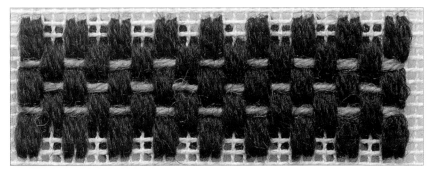

3. Twist a length of thread to form a cord rather longer than the length of the row. Insert your needle under the stitches already in place and run your needle and cord under the double stitches. Take the cord through to the back of the work and finish off.

Tip
To get the full effect, use a second colour for this next stage.

Florentine stitch

Florentine stitch consists of wave patterns made with parallel straight stitches. The patterns are usually regular and may be worked with different sizes of stitches and different rises and falls to suit your own requirements. Random Florentine patterns are also very attractive.

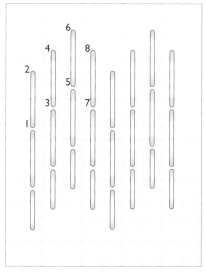

1. Make your first line of stitches so that the top of the wave reaches the top of the area to be stitched.

2. Work rows of similar stitches under the first line in the same wave pattern. Different lines of stitches may be over different numbers of horizontal threads in different colours.

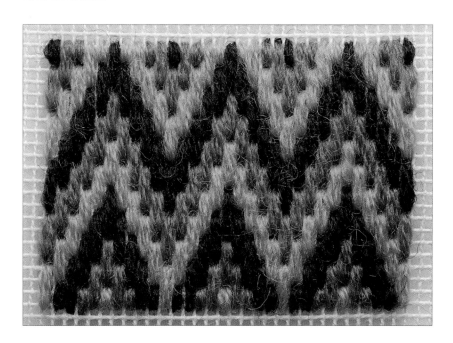

Tip

Tension must be very even for this stitch to look its best and the stitches must all be made in an 'over and over' way otherwise the stitches will not lie straight.

This sample has been stitched in the same wave pattern used in the Spectacles Case project.

Triangle stitch

This easy and quickly worked stitch is made up of four straight stitch triangles which are usually worked over 2, 3, 4, 5, 4, 3 and 2 canvas threads as shown on the diagram. A cross stitch is placed in each corner to fill in the bare threads. These crosses may be worked in a second colour if desired. A single triangle stitch looks attractive on its own as an individual motif.

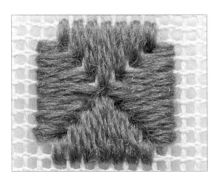

1. Work round the square placing each of the four triangular straight stitch sections in turn.

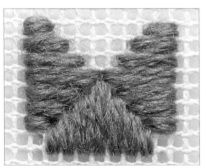

2. Complete the four triangles to form a square.

3. Work as many triangle stitches as required and then put in the cross stitches (see page 36) at the corners of each square.

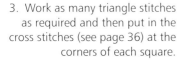

35

Cross stitches

Cross stitch

Cross stitch is one of the basic stitches in needlepoint and has many variations. Because they are made up of two diagonal stitches covering a square of canvas, cross stitches do not distort the canvas at all. A cross over two canvas threads is the most used cross stitch in needlepoint projects.

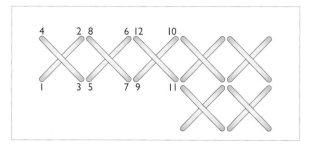

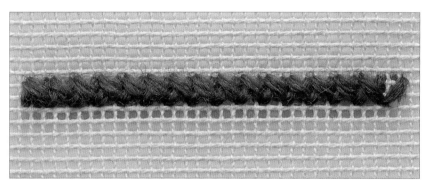

1. Make the first stitch over two canvas intersections from bottom left to top right and the second from bottom right to top left. Work the second cross starting from the bottom right of the first.

2. The second row is worked in the same manner back from the end of the first row. All the top stitches should lie in the same direction, unless you choose to make alternate stitches or alternate rows have a variation.

You can make horizontal and vertical stripes with lines of cross stitch.

Smyrna cross stitch

Smyrna cross stitch is worked over a square of four canvas threads, and although it does not cover the canvas as well as rice stitch (page 46) or double leviathan stitch (page 42), it has a good sculptured appearance and any canvas showing through can appear as part of the charm of the stitch.

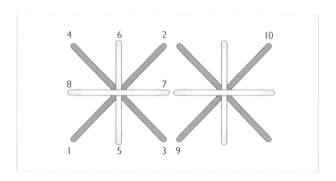

1. Start with a diagonal cross stitch over four intersections of the canvas.

2. On top of this place a straight cross stitch. Finish one complete stitch before going on to the next.

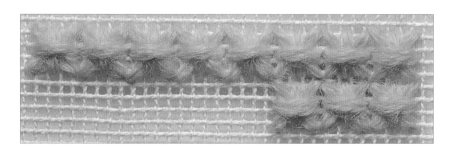

3. Work in alternating lines from right to left then left to right, making sure you consistently put the horizontal stitch on top.

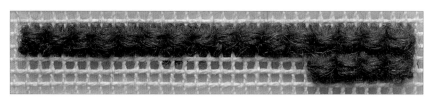

Smyrna cross stitch can also be worked across a square of two canvas threads in which case it makes a very hard, dense stitch useful for flower centres such as in satin flower stitch (page 69).

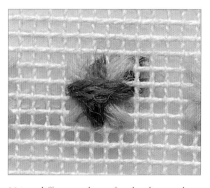

Using different colours for the diagonal and straight cross stitches makes a good variation.

Single cross stitch

Single cross stitch forms a very small, hard, bead-like stitch in which it is very difficult to see the cross formation with the naked eye. It was used in the past for large canvases as it is incredibly hard-wearing.

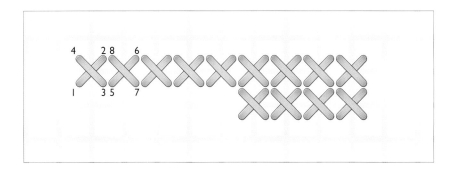

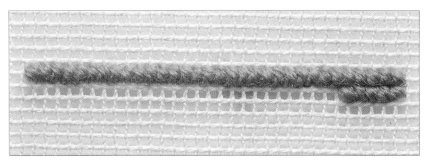

1. Two diagonal stitches are made across the intersection of two canvas threads; bottom left to top right and then bottom right to top left. This is then repeated to the end of the row. The second row may be made from right to left but the stitch is made in the same way.

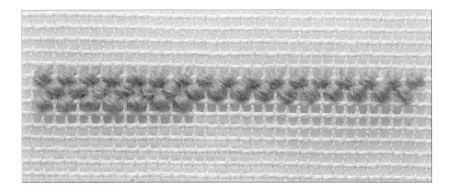

Single cross stitch may be used as a decorative stitch if worked into every other canvas intersection and staggered on each row.

Upright cross stitch

Upright cross stitch has a very firm and neat appearance, densely covering the canvas. It is not quick to work, but the result is worth the effort involved.

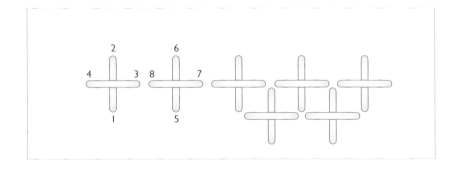

1. Make the upright crosses over a square of two horizontal and two vertical threads. The horizontal bar of each cross is made backwards into the hole already occupied by the previous cross.

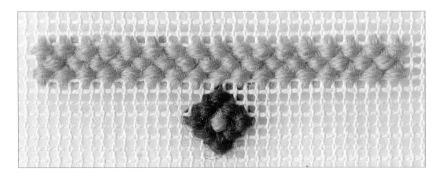

Decorative patterns can easily be made with this stitch by carefully placing the upright cross stitches and using more than one colour.

Fern stitch

Fern stitch is worked down the canvas and is an easy stitch to work once you have got the hang of it. Usually worked into every other hole as you move down the canvas, it can be worked into every hole, in which case it forms a very solid and thick cover.

1. Bring your thread out at the top left of the area to be worked. Count across three vertical threads and down four horizontal threads before putting your needle through the canvas. Bring your needle and thread up again two threads to the left. Take the needle and wool down through the canvas four threads to the right of the first entry to complete the first stitch.

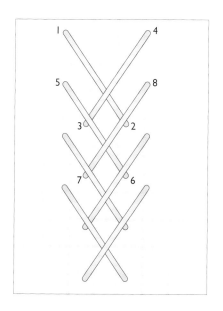

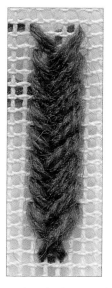

2. The second and subsequent stitches are started two threads down from the previous stitch and worked in the same way.

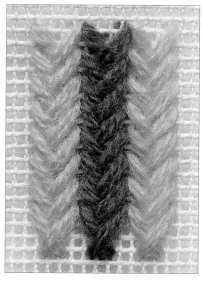

3. When more than one vertical row is worked, no space is left between the rows.

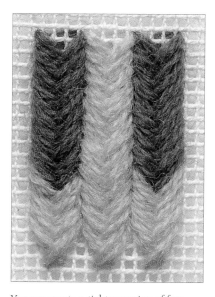

You can create a tighter version of fern stitch by working into every hole rather than every other hole down the canvas.

Tip

If necessary, you can work short diagonal compensation stitches into the gaps at the top and bottom of the rows.

Crossed gobelin stitch

Crossed gobelin stitch is large, easily worked and covers well. It looks knobbly and handsome as a filling stitch.

1. The first part of crossed gobelin stitch is a straight vertical stitch over six horizontal canvas threads. Next a cross stitch over a square of two threads is made over the centre of this upright thread as shown in the diagram.

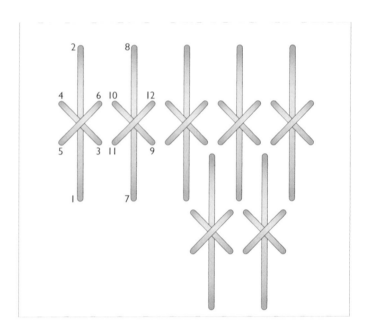

2. Place subsequent stitches two canvas threads to the right of the base of the first stitch and carry on in the same way to the end of the row.

3. Start the second row four canvas threads below the base of the first row, placing the second row stitches between those of the first row, so that the tops of the second row stitches share holes with the crosses of the first row.

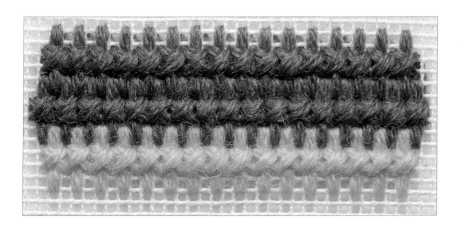

You can insert rows in different colours in patterned work.

Double leviathan stitch

Double leviathan is a raised stitch with a very three-dimensional appearance. It consists of four different large crosses worked on top of one another. As such it is a very firm and hard stitch, useful as a contrast to flatter stitches. Usually the upright cross is worked on top.

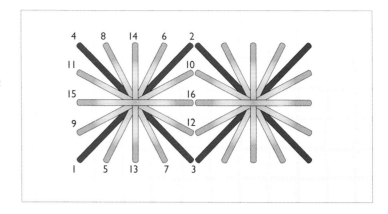

1. Work the first cross. I have used different coloured threads to illustrate the stitch.

2. Work the second cross over the first as shown.

3. Work the third cross over the top of the second cross.

4. Work the final cross.

You can work double leviathan stitch in rows or as single motif stitches, set into a flatter stitch such as half cross stitch.

Dramatic coloured patterns can be achieved with double leviathan stitch, when several stitches are massed together.

Long-legged cross stitch

Long-legged cross is a firm plait-like stitch. It is very useful as an edging stitch on items such as spectacles cases and needlecases as it is dense enough to be sewn into when joining edges. Work three rows if you want to form a spine on a needlecase or similar item, while two rows are ideal for forming a right-angle edge, for use on a box cushion, for instance.

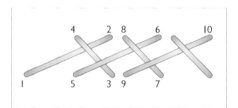

1. Work the long leg first, over four vertical threads and two horizontal threads. Bring the needle out two threads below the end of the stitch, and take the needle and thread back over the long leg to the top row, two vertical threads to the left of the end of the stitch to complete the stitch.

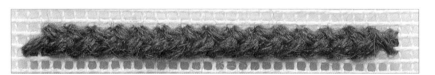

2. To work the second and subsequent stitches, bring the needle out to the front two threads below where you have just gone in. This hole is very likely to be partially masked by the wool, so work carefully.

To help to show you how the stitch is formed I have worked alternate stitches in a different colour so you can see how they fit together.

3. When starting a row you will want a flat end, not a projecting long leg, so start the row with a cross stitch over a square of two threads.

4. Start your long leg from the bottom left of this cross, working over it, as shown.

5. When working more than one row of long-legged cross it is necessary to work all the rows in the same direction if you want the plait effect to be the same in each case. It is easier to work extra rows underneath a previous row rather than above it. The green row is worked under the fuchsia row.

Long-legged cross stitch variation: This variation of long-legged cross stitch is worked over one horizontal canvas thread and three vertical canvas threads. It forms a very neat narrow line with a beaded effect. This stitch looks very pleasing in cotton perle or stranded cottons.

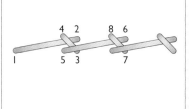

43

Norwich stitch

Norwich stitch is a handsome cross stitch which has great depth if worked over a large square. The stitches show up to advantage if worked in mercerised cottons which catch the light. Fine gauge cottons show the formation of the stitch well.

To work the stitch easily it is important to understand the logic of its construction. A basic cross is made first, over an uneven number of canvas threads. After this, as the numbering on the chart shows, all stitches are made parallel to one or other of the arms of the first cross, looping along the edges of the square on the back of the work until they meet in the middle of each side. Follow the numbering carefully, emerging at an odd number and entering at an even one.

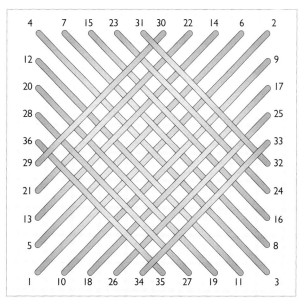

Note that 35–36 is worked underneath 29–30.

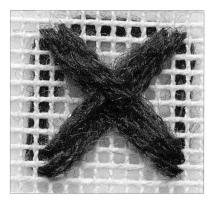

1. Work the basic cross over a square of nine canvas threads. When you have made the base cross, bring your needle out at hole number 5 and work across to hole 6, out at 7, in at 8 and so forth.

2. Following the numbering carefully, continue working the stitch.

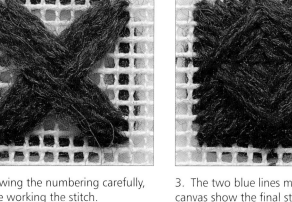

3. The two blue lines marked on the canvas show the final stitch coming to the front (at the bottom of the picture), and going through to the back of the work behind an already-worked section.

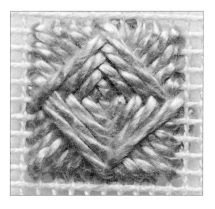

Norwich stitch shows up very well if worked in mercerised cotton.

Rhodes stitch

Rhodes stitch can be worked over a square of any number of threads, but looks its best when worked quite large. It forms a high pyramidal shape which is held together by a final binding stitch across the middle.

Rhodes stitch is an easier stitch to work than Norwich stitch, but lacks its sculptural quality.

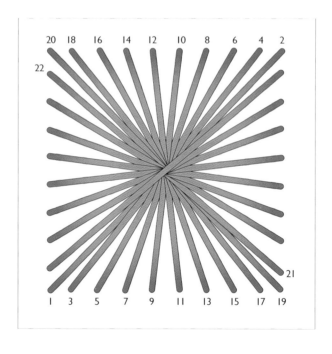

1. Work in an anti-clockwise direction along the bottom and top of the stitch, following the numbering on the diagram.

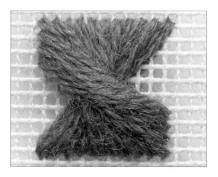

2. Continue working in an anti-clockwise direction around the square, working up the right side and down the left side of the square until every hole has been filled. Finish the stitch by making a short tying-down stitch across the middle of the pyramid of wool.

Rhodes stitch may be worked in more than one colour and type of thread. Change the thread to work the final part of the stitch.

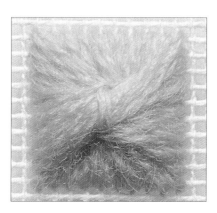

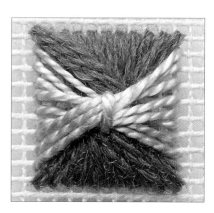

Rice stitch

Rice stitch is one of the most popular needlepoint stitches for use in patterned pieces of work. It is very versatile as it may be either a one- or two-colour stitch, and the appearance can be changed entirely by reversing the two colours.

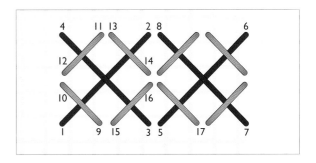

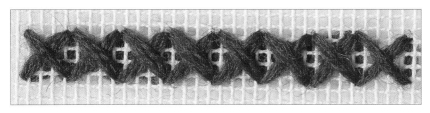

1. Stitch a row of large cross stitches over a square of four canvas threads, making sure that the same arm of each cross is on top.

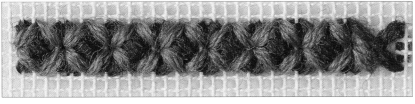

2. Work short stitches across the corner of each cross stitch from the middle hole between any pair of legs to the middle hole between either adjacent pair of legs. Work round one cross and then move on to the next.

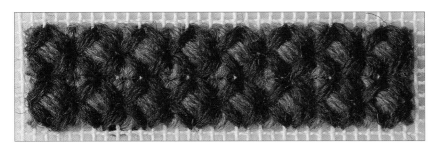

By reversing the colours of the cross and the top stitching you can change the look of the stitch.

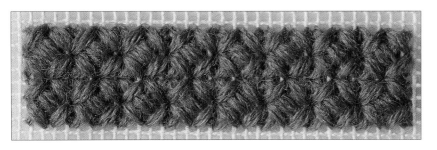

You can also work rice stitch in one uniform colour to make a firm background stitch.

Algerian eye stitch

Algerian eye stitch is a simply worked eyelet stitch in which eight short stitches are made into the middle of a square of four canvas threads. If you are working on interlock canvas you should open up the centre hole with a large needle before starting to stitch.

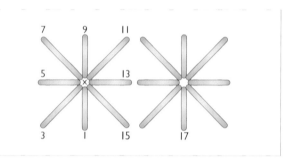

All of the even numbers of the first Algerian eye are at the point marked 'X'.

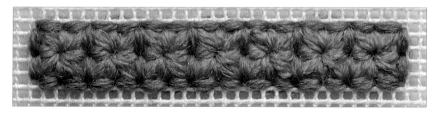

1. Open up a hole in the centre of the first square of four canvas threads and work short stitches into the centre from alternate holes round the edge, starting at the middle hole of the base. Before starting on the next stitch open up the hole in the centre of the square.

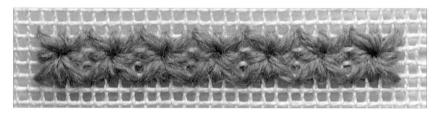

2. Work the second row back towards the left-hand side of the work, opening up the centre holes as you move along.

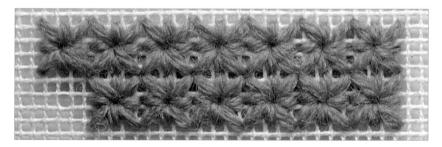

If you want to hide the background canvas you can surround each eyelet with back stitches over two canvas threads.

Pile stitch

Turkish knot stitch

This is the only pile stitch featured in this book, and in my opinion is the best pile stitch to use for needlepoint. It can be used on any gauge of canvas to make a small carpet, to represent fur or foam on water. The pile can be any length required, but will only stand upright after several rows have been worked. Each stitch is formed round two vertical canvas threads.

Tip

Be careful not to catch your needle in the wool already in the hole when making the second pass.

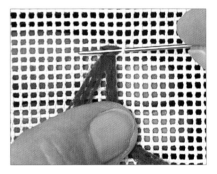

1. Start at the bottom of the area to be covered. Hold the wool down on the front of the canvas. Take your needle through the canvas and back, pulling all the wool through apart from that forming the length of the pile.

2. Holding this pile down with your left thumb, and keeping the working thread above the line of stitching, pass the needle behind the canvas thread immediately to the right of the first vertical canvas thread.

3. Pull the thread through to form the knot, then start the next stitch, allowing the same amount of wool as before for the pile. Make another knot in the same way as the first, leaving no gaps.

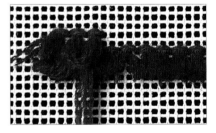

4. Work a line of knots, holding loops for the pile below the line of knots at all times. Keep the loops for the pile longer than required as you will trim them later. The pile can be worked round a pencil or knitting needle if you find it easier.

5. Cut the loops to form the pile and trim to the length required by pushing the loops upright with a card gauge of the height required and trimming off the excess wool with a pair of scissors.

6. The second and successive rows are worked above the first, leaving a line of empty holes (two horizontal canvas threads) between each row. Continue cutting the pile after each row. Patterns are built up by placing different coloured loops in the rows.

Turkish knot stitch produces a very dense effect. This is shown in the miniature carpet (inset) that has been worked in this stitch.

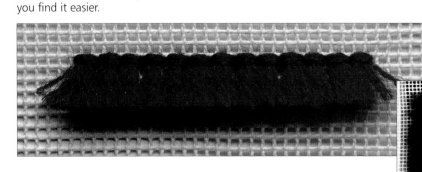

Leaf stitches

Leaf stitch

Leaf stitch is a handsome and three-dimensional stitch which has many uses. It looks good when used singly or as a multi-leaf motif set in half cross stitch, but can also be worked very successfully as an all-over background stitch. There are several ways of working the leaf but after experimentation I have decided that the method shown here is probably the easiest way to achieve a perfect result. Any problems usually arise because the stitches on the canvas tend to mask the next hole to be used. Pull the wool already on the canvas aside if you are in doubt as to whether you are stitching into the correct hole.

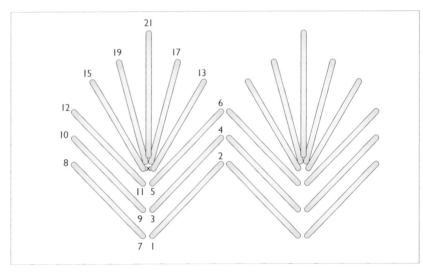

All of the remaining even numbers of the first leaf are at the point marked 'X'.

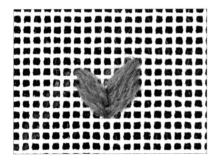

1. Following the numbering on the chart, first work the three right-hand side diagonal stitches at the base of the leaf one above the other over three intersections of the canvas, from the centre of the leaf to the outside. Begin to work the diagonal stitches on the left-hand side to match the first group, again starting from the base.

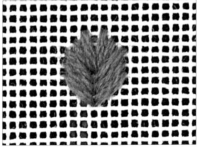

2. The five stitches making up the top of the leaf are all worked down into the next empty hole above the diagonal stitches already on the canvas. Work one on the right-hand side, then from the left (these are one thread higher than the first diagonal stitches, and one thread nearer the centre), then from the right again, then from the left (these two stitches are again one thread further up and one thread in towards the centre).

Tip

If you are joining one leaf to another on the left, you will find it best to work the left-hand side base stitches first.

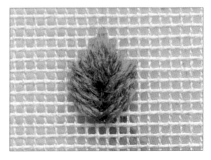

3. There is now just one line of holes between the two top stitches. The topmost stitch of the leaf is one thread higher than all the others and is worked into the same hole as the four most recently worked stitches.

Tip

When joining four leaf stitches back to back to form a motif, you should work all the lowest base stitches into the same hole.

Leaf square stitch

Leaf square makes a handsome background stitch which is quick and easy to work once you have mastered it. You can vary the appearance with different colours if you wish, either in whole leaves or in sections of single leaves. It is best worked in a diagonal fashion down and up the canvas.

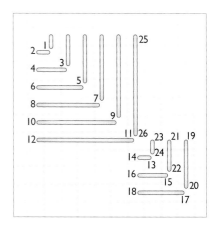

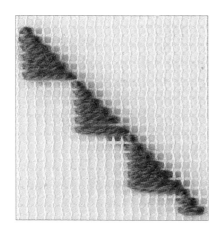

1. Start working from the top left of the area to be covered. You will be able to add extra leaf squares either side of your worked area eventually, if you wish. Work parallel horizontal stitches from right to left over 1, 2, 3, 4, 5 and 6 canvas threads. Work down the canvas as shown on the diagram.

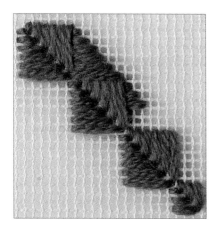

2. Complete each leaf by working up the row of stitches, inserting parallel vertical threads downwards over 6, 5, 4, 3, 2 and 1 canvas threads. The second row of leaf squares is started with the first five stitches tucked under the edge of the first leaf. The longest stitch goes into the bottom of the first leaf.

3. Make sure that the centre holes in each line of leaves form a straight diagonal line as you build up the stitchery.

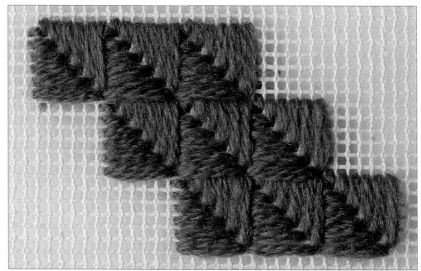

Leaf stitch variations

You will find it useful to have diagrams for various types of leaf shapes, so here I have given you five different ones. Any of them can be made to face the opposite way, if that is what you need.

I have made you a sample of each stitch to show you what they look like.

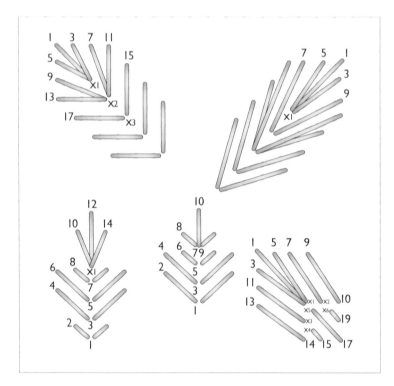

Where numbers are missing, work into the points marked X in numerical order (X1, X2 etc) until the next number becomes available.

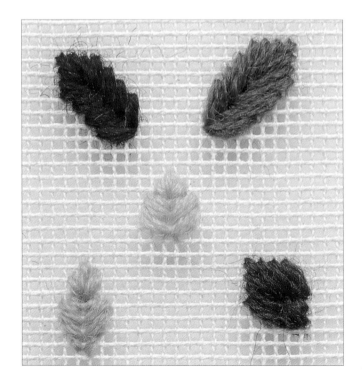

Follow the diagrams very carefully, noting the exact position of your next stitch in relation to the one you have just completed.

Diagonal stitches

Cushion stitch

As its name implies, cushion stitch has the appearance of neat lines of small cushions. These are made up of groups of diagonal stitches facing two different ways, each group forming a square.

This is an easily worked stitch and the threads catch the light in an attractive manner.

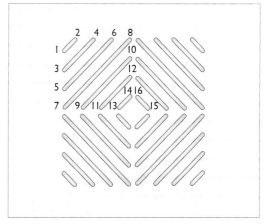

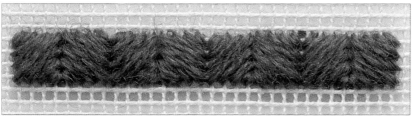

1. The squares are worked over 1, 2, 3, 4, 3, 2 and 1 canvas intersections, firstly from top left to bottom right and then to form the second cushion the stitches are worked in a similar way from bottom left to top right.

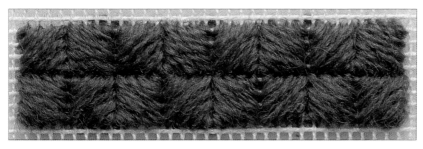

2. On the second row the manner of working the squares is alternated to make a chequerboard pattern.

For a two-colour chequerboard pattern it is easier to work the squares diagonally down the depth of the area to be covered using alternately first one colour and then the other. Use two needles, one for each colour.

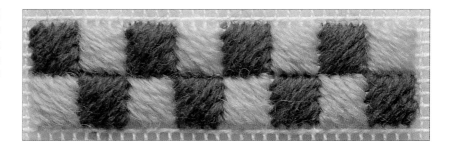

Diagonal ground stitch

This is an attractive stitch and is easily worked but should not be used to cover large areas as it distorts the canvas badly. This can be controlled to some extent by using a frame.

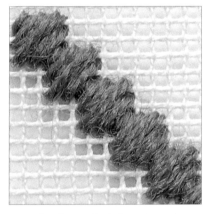

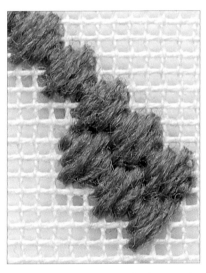

1. Make diagonal stitches down the canvas over 1, 2, 3 and 2 intersections of the canvas and then repeat the sequence as desired.

2. The second row is worked upwards from the bottom of the first row. Place the longest stitch up against the shortest stitch of row one.

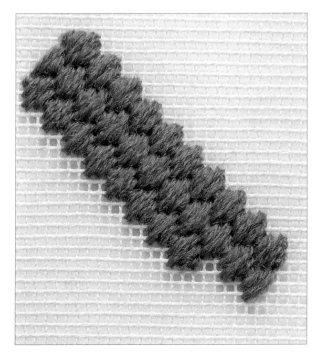

3. Continue working rows in this manner. Distortion of the canvas may begin after only two rows have been worked. You can mitigate this by not pulling the threads tightly, though still maintaining an even tension.

Diagonal ground stitch may be worked as a two-colour stitch, and subtle graduations can be introduced for pictorial work. Be careful with the compensation stitches, making sure that the square edges of each motif are maintained.

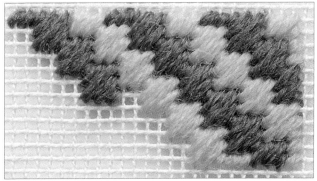

53

Diagonal mosaic stitch

Diagonal mosaic stitch is a small and neat easily worked stitch. It is formed over one then two canvas intersections down a diagonal and then repeated. As is the case with all diagonal stitches, diagonal mosaic stitch will distort the canvas if worked over large areas.

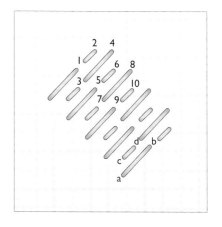

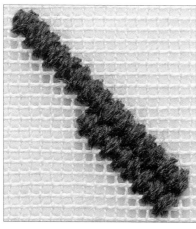

1. Work a line of stitches over 1 then 2 intersections of the canvas down any diagonal.

2. Work the second row upwards from the bottom of row one, placing the longer stitch against the shorter stitch of the preceding row.

Tip

If you find it difficult to follow a single diagonal with your stitches, mark the line to be worked with a pencil before beginning.

You can produce striped patterns with this stitch, and corners are easy so long as you are careful with the compensation stitches. You can put in extra rows from either side of the rows already worked.

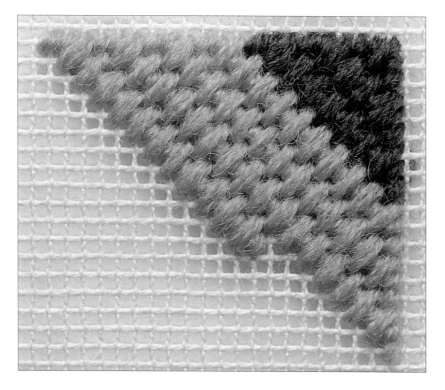

Fan stitch

Fan stitch is a simple stitch which you can use for a background or in patterned pieces. Form it round a square of four canvas threads. Although it does not seem to cover the canvas very well as you are making it, when you have worked several rows it forms a fairly dense cover.

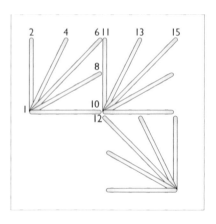

All of the remaining odd numbers of the first fan are at point 1.

1. All the parts of a right-facing fan are worked from (or into) the bottom left-hand hole of the square of four canvas threads. Start at the bottom left with the upright stitch and work into every other hole round the square.

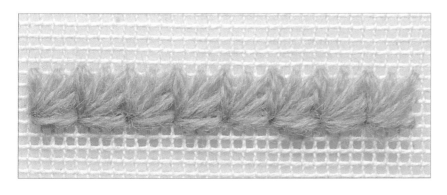

2. As you cannot work out of a hole you have just entered, you must work every other fan from the outside of the square into the bottom left hand corner, starting with the upright stitch.

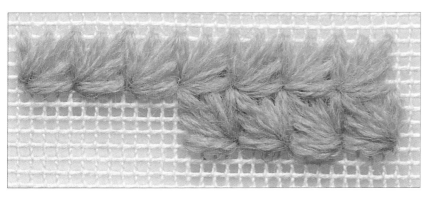

Here I have started the second row with fans facing to the left, which forms a contrast with the top row.

Stem stitch

By using stem stitch you can give outlines the appearance of smoothness which would otherwise appear stepped on account of the canvas squares, or you can use it to outline an area to be filled in. You can also use back stitch for this purpose, which gives a slightly finer line.

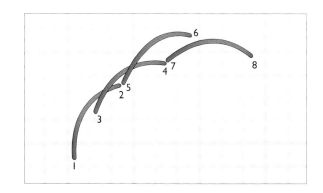

1. Anchor your thread and make similar length stitches in the directions required. The needle is brought out about a third of the way back along the stitch (either above or below depending on which direction the line is next going).

The green line of stem stitch shows how the squared edging of the tent stitch has been masked along the edge.

Lattice stitch

Lattice stitch is a small, neat stitch which you can make very decorative by placing several different colours in the diamond-shaped frames.

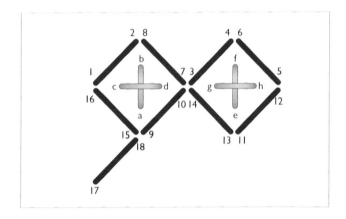

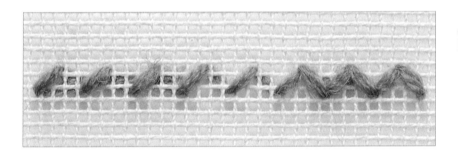

1. Follow the numbering on the diagram to work the top half of the line of frames first.

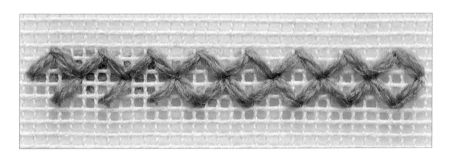

2. Fill in the lower part of the frames on the return. Finish all the four-sided frames on a row before filling the centres. You can work all the frames required before starting on the filling if you wish.

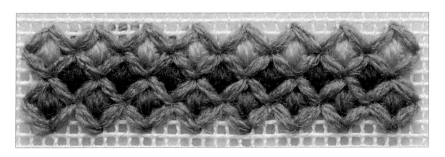

3. Fill in each frame using upright cross stitch, following the alphabetical sequence.

Tip

The filling stitches can be made in one colour or contrasting colours. Upright cross is the best stitch to fill, but you could also use a French knot (page 66).

Milanese stitch

Milanese stitch is a handsome diagonal stitch which forms a wave-like pattern across the canvas when a few rows have been worked. It is useful for skies in a picture as subtle colour variations can be introduced by mixing threads in the needle.

As with all diagonal stitches, Milanese will distort the canvas, but not as badly as some of the smaller diagonal stitches.

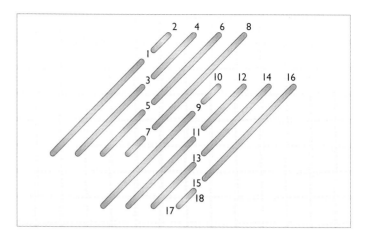

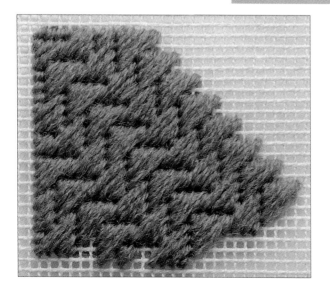

1. Work diagonal stitches across 1, 2, 3 and 4 canvas intersections and then repeat.

Tip

If you find it difficult to follow the diagonal line, especially with the smallest stitch, draw a faint pencil line down the diagonal you are working across before you begin the first row.

Tip

As you work, you will notice that the edges of each group of four stitches, both vertical or horizontal, form straight lines.

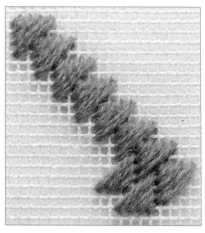

2. Work up the second row, positioning the smallest stitch up against the longest stitch of the first row and the longest stitch against the shortest stitch of the first row.

3. It is often difficult to see where to put the compensation stitches in Milanese stitch. When you are starting a new row where compensation stitches are needed, put in a full-size stitch further down the row first and then go back to put in the compensation stitches when it is more obvious where they should be placed.

Mosaic stitch

Mosaic stitch is a small, neat stitch which appears to be made up of squares. It is worked in groups of three diagonal stitches.

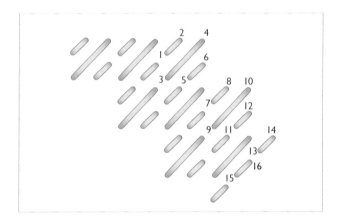

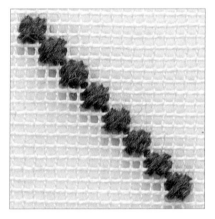

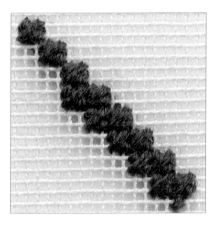

1. Work diagonal stitches across 1, 2 and 1 canvas intersections and then repeat. As two small stitches follow each other it is easier to follow the diagonal line than in some other diagonal stitches.

2. The second and succeeding rows are worked up and down the canvas, the long stitches going into the holes between the two short stitches of the preceding row. Extra rows can be put in place from either side of the block of mosaic stitches.

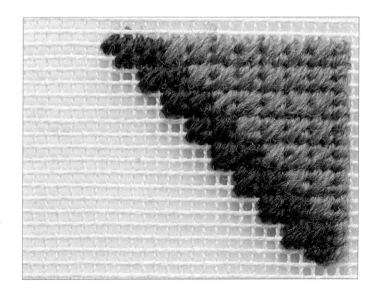

Compensation stitches are easier to work than on larger diagonal stitches. You can insert rows in different colours for contrast.

59

Half cross stitch

Half cross stitch is one of the three smallest needlepoint stitches. All these stitches look similar on the front of the canvas, but have distinct differences in their form and usefulness. As its name suggests, this stitch is the first half of a cross stitch and is very simply worked. On the back of the work there is a small upright stitch which results in the stitch being very stable with no tendency to pull your canvas out of shape.

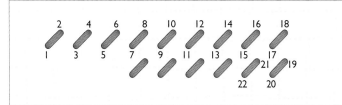

The lack of a strong backing means however that this is not a stitch which should be used for any item which will need to wear well, such as a kneeler, rug or stool top.

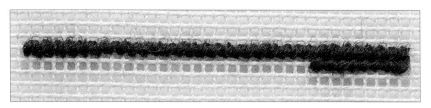

1. Work stitches from bottom left to top right over one intersection of the canvas and repeat to the end of the row. On the second row, which is worked back underneath the first, you must make the stitches from top right to bottom left. If working the second row seems clumsy, you may find it easier to turn the work upside down and work the stitch in the same way as the first row.

2. Turn the work the right way up again for the third row, and follow this method, alternating direction with each row, to complete your work.

Tip

If you look on the back of your work and find you have one row of upright stitches followed by a row of sloping stitches, then you are working alternate rows of half cross stitch and continental tent stitch which will not look even on the front of the work.

I have shown the back of a row here so that you can see what the stitches should look like.

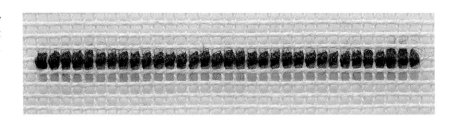

Continental tent stitch

Continental tent stitch (the second of the three smallest stitches) is not much used today because although a very strong stitch, it distorts the canvas badly and it is not always easy to pull the work back into shape in the finishing process.

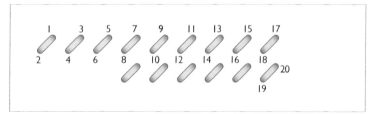

1. Work stitches from top right to bottom left over one intersection of the canvas. On the second row work the stitches back from bottom right to top left.

2. Follow this method, alternating direction with each row to complete your work.

Here I have shown the reverse of the work so that you can see that the back of the work is covered with long diagonal stitches which give strength to the finished product, but also cause the distortion.

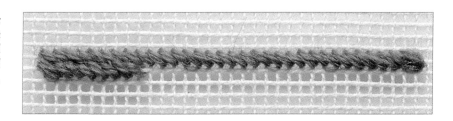

Basketweave tent stitch

Basketweave tent stitch (the third of the smallest stitches) is a relatively modern stitch which combines the strength of continental tent stitch with the lack of distortion of half cross stitch. Instead of being worked in horizontal rows this version of the smallest stitch is worked up and down the diagonals. This results in the back of the stitches being at right angles to each other along the weave of the canvas – hence the name basketweave.

These features make this the best of the small stitches to use for large areas which need to wear well.

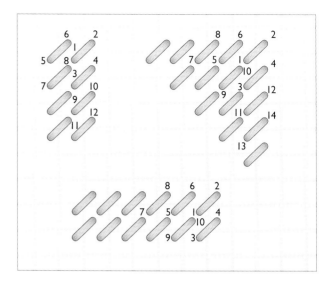

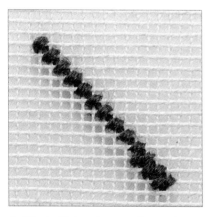

1. Work stitches down a diagonal across one intersection of the canvas. The second row is worked up from the bottom.

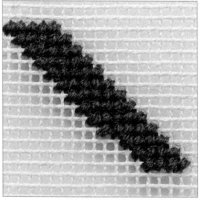

2. Work up and down along the diagonals (you can work in from either side), placing the stitches into the gaps left by the previous row.

Tip

When using basketweave tent stitch, break off for rests in the middle of a row so that you know which way you are working along the diagonal. If you work two rows in the same direction, the work will look uneven.

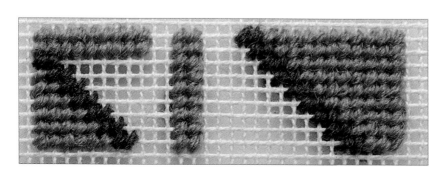

Basketweave tent stitch can be used for two horizontal or vertical rows, and can easily form neat corners, as these examples show.

Web stitch

Web stitch is worked in two stages and usually in two colours. It forms a very neat pattern, completely unlike any other needlepoint stitch. Base stitches are laid along the diagonals and then tied down by small stitches in the different colour (if used).

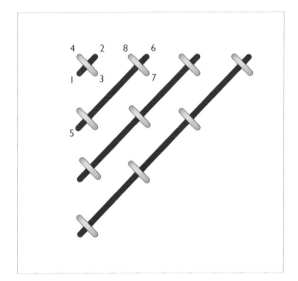

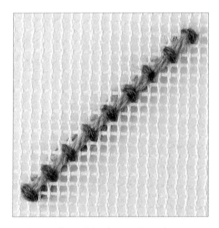

1. Lay a thread in the main colour along a diagonal of the canvas. With the second colour threaded in a different needle, tie the thread down over every other intersection along its length.

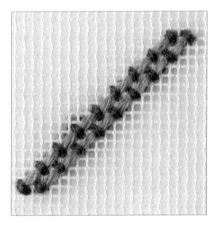

2. For the second row, lay another thread in the main colour as long as required parallel to the first. Start off two holes to the right of the end of the previous row. Tie down in the same way, staggering the second colour to give a woven appearance.

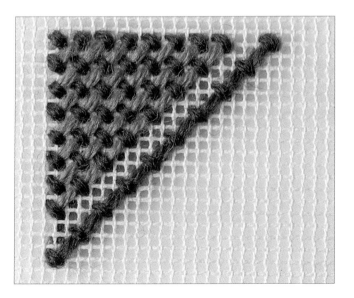

You can make a very neat corner with web stitch. The threads to be tied down can be of any length, but must not be laid down too loosely nor so as to buckle the canvas.

Woven plait stitch

Woven plait stitch is small and neat with an unusual woven effect. It is easily worked once you have got the hang of pushing the stitches under those of the preceding row.

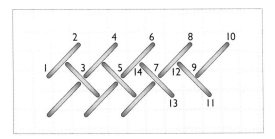

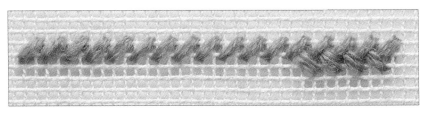

1. Work diagonal stitches from bottom left to top right over two intersections of the canvas leaving one hole (two threads) between each stitch. Work the second row from right to left over two canvas intersections, as before, but with the stitches facing the other way. Follow the numbering on the diagram.

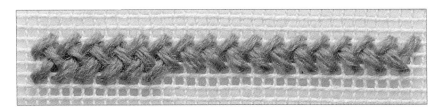

2. In the second and subsequent rows, the stitches will have to be pushed into a hole which is masked by the stitches of the preceding row. Be careful not to catch these threads when stitching.

The lines can be varied in colour or shaded to suit your requirements.

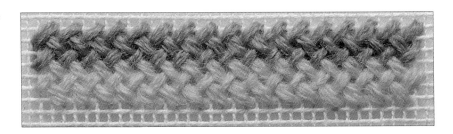

Tied stitch

Graduated sheaf stitch

Graduated sheaf stitch with its tied, pointed sheaf shape is a great favourite of mine. It is a useful stitch which is at home in patterned work or landscapes, where it can make good tree shapes.

1. Lay down the five parallel straight stitches which form the basis for graduated sheaf stitch. These are over 4, 6, 8, 6 and 4 horizontal canvas threads respectively.

2. Run your needle down the right-hand side of the longest stitch and draw it aside to show the empty holes behind. Pull your needle and all the woollen thread through the middle hole from the back to the front of the work.

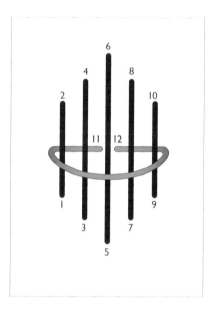

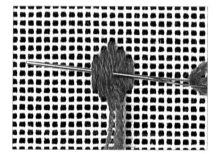

3. Take the needle and thread back under the wool in front of the middle hole and gently slide the needle under the straight stitches to the left of the longest stitch (still on the front of the canvas) and out at the left-hand side of the stitch.

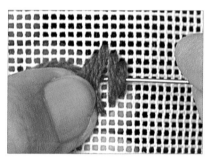

4. Take the needle and thread over the front of the stitch, in again under the right-hand two stitches and down through the middle hole to the back of the canvas, pulling the wool tight to 'bind' the sheaf.

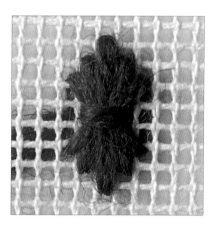

The finished graduated sheaf stitch motif.

Knotted stitches

French knot

The French knot is a much used stitch in needlepoint and is easy to work once you have been shown the correct method. You must aim to have the knot resting directly on the canvas or stitchery on which it is placed. French knots can be used singly or massed together to form any shape you like – they are very effective as clouds as colour mixing is easy both in the needle and in the mass of stitchery.

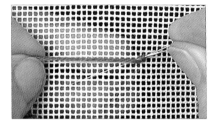

1. Anchor your thread firmly on the back of the work. Bring your needle and all the thread through to the front of the work where you want to place your knot. Hold the thread fairly tautly about 3cm (1¼in) away from the canvas. Twist the needle round the thread in a clockwise direction once (small knot) or twice (large knot).

2. Twist the needle with the thread round it down towards the canvas and insert into the hole to the top or left of where you came out. Still holding the wool firmly in your left hand run the knot down on to the canvas and carefully pull the needle through to the back of the work.

The completed French knot.

> ## Tip
> If you are making a knot on top of stitchery already on the canvas you will have to feel around for the holes in the relevant areas.

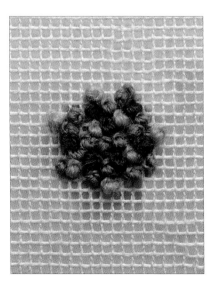

Massed French knots look most attractive.

French knot on a stalk

French knots on stalks are decorative features which you can use for the centres of large flowers. The stalk can be made any length you choose and the knot can also be varied in size to suit your purpose. You can also make these knots on top of stitchery already in place.

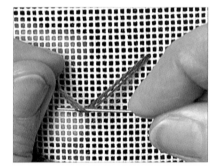

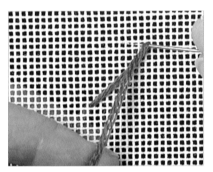

1. Anchor the thread firmly on the back of the work and pull the needle and all the thread to the front of the canvas. Hold the thread firmly about 3cm (1¼in) away from the canvas. Wind the thread round the needle in a clockwise direction once, twice or three times to suit your requirements.

2. Twist the needle with the thread round it down towards the canvas and insert into the canvas where you want the knot to rest.

3. Still holding the wool firmly in your left hand, run the knot down on to the canvas while holding the needle upright on the back of the work with a finger. Carefully push the needle down into the canvas before pulling through from the back. Tie off the wool to complete the knot.

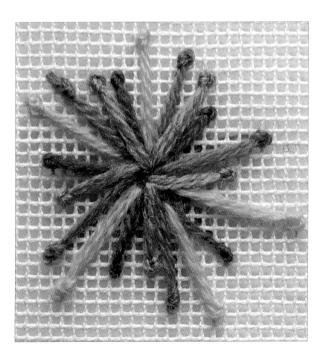

You can make very decorative shapes with this stitch.

Knotted gobelin stitch

Knotted gobelin stitch is a large, handsome stitch which slants and is made over the unusual number of five canvas threads. As with many needlepoint stitches, once the first row is in place, working the stitch is quite easy.

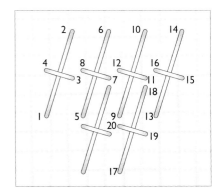

1. The stitches in the first row are worked over five horizontal and two vertical canvas threads with two canvas threads left between each stitch. When the main part of the stitch is in place the tying down thread is placed across two vertical canvas threads and one horizontal thread as shown on the diagram.

Tip

Take some time getting the first row correct and then the second and succeeding rows will be easy.

2. The stitches of succeeding rows fit neatly into the gaps left in the first row, and the tying down threads are made at an angle into the base of the stitches of the preceding row.

Knotted gobelin stitch lends itself to shading and use of different colours as the rows interlock in a very attractive fashion.

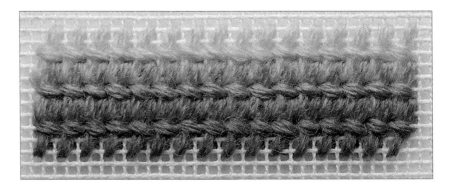

Motif stitches

Satin flower stitch

Satin flower stitch is a pretty, easily worked stitch which has many uses. You can place it on its own as a motif, use it as a continuous border in a patterned piece of work or place scattered flowers in a background of small stitches.

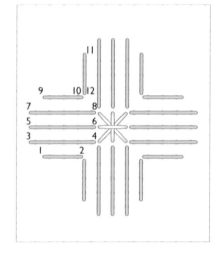

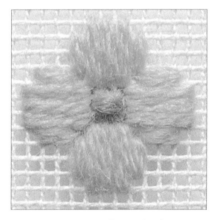

1. Work each petal in turn, starting with the one on the left-hand side. Make straight horizontal stitches over 3, 5, 5, 5 and 3 canvas threads. Once complete, move on clockwise to the next petal, working the first stitch over three threads vertically downwards into the right-hand end of the final stitch of the petal just worked. Move on to the third petal.

2. Work round the flower in this manner until you have just a square of four threads in the centre of the flower. Fill this with a small Smyrna cross stitch (see page 37) in a second colour.

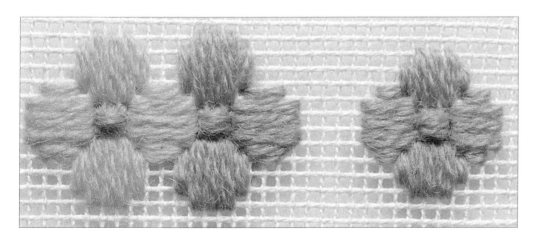

You can build up various patterns of flowers by using different colours. You can also work a smaller flower with a petal worked over 2, 4, 4, 4 and 2 canvas threads.

Spider's web stitch

Spider's web stitch is a round, three-dimensional stitch which is useful for special effects. You can group them together if you wish but I think they make more impact on their own as a motif set in either half cross or basketweave tent stitch.

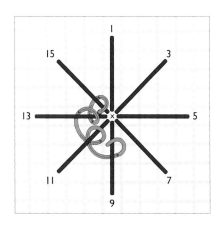

All of the even numbers are at the point marked X.

1. First you must lay down the framework for the second stage of the stitch. Work eight stitches into the centre hole as shown. Keep a firm tension, otherwise your web will not have straight ribs.

2. Bring your needle out between two of the legs at the top left of the framework, as close to the centre as you can get without coming through the centre hole. The rest of the stitch is worked on the surface of the canvas.

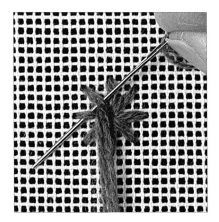

3. Take the needle and thread back over one rib and then forward under two ribs, keeping the centre hole towards you and turning the work, making sure not to catch any threads with your needle as you pass under them. Pull the stitches gently towards the centre as you work.

Tip

These stages are sometimes easier to do with the canvas laid down on a table.

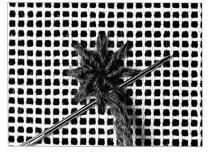

4. Keep working round until you feel the whole web is filled – and then do another round! Take the needle through to the back of the work and fasten off your thread.

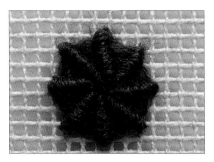

The completed spider's web stitch motif.

Wheel stitch

Wheel stitch makes a hard round upstanding motif, rather like an old-fashioned fabric button. It is very useful for making the centre of a flowerhead.

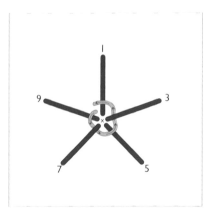

All of the even numbers are at the point marked X.

1. First you have to lay down the framework for the second stage of the stitch. This looks rather an odd shape as it has to have five arms. Work as shown in the diagram, and make sure the tension is firm, otherwise you will not be able to make a satisfactory stitch.

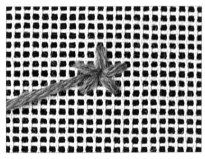

2. Bring your working thread to the front of the canvas between any two of the arms near the centre. Work under and over alternate arms of the framework on the surface of the canvas. Pull the thread towards the centre as you work.

3. Continue until the wheel is as tall and hard as you require. As more thread is added round the outside the wheel gets progressively higher. When you are happy with the result push your needle through to the back of the work and fasten off the thread.

The completed wheel stitch motif.

Spectacles Case

The first project is a useful spectacles case, which can be worked using any of your favourite stitches. I have used eleven stitches, all of which are illustrated in the book. I have chosen bright colours that show up well in an illustration, but you may wish to choose more subtle shades.

 You should use three strands of crewel wool throughout the project. As the quantities required will vary depending on which colours you use for each stitch, it would be best to start with half a hank of each colour. You will then have plenty of wool however you use it.

Method

Mark out the outlines of your spectacles case on the canvas using an HB pencil. The worked area will cover approximately 16½ x 18cm (6½ x 7in), so decide approximately how much space you must leave all round before starting to mark out your work.

Tip

Remember it is easy to count threads with your blunt-ended needle.

Tip

Notice that the threads across the panels of the case are in multiples of four. This is to make it easy to use the many stitches, such as rice, that cover four threads.

1. Bind your canvas and trace the chart opposite using a pencil.

Key for the chart (opposite)

1. Mark the canvas to work long-legged cross stitch.

2. Work six rows of half cross stitch here.

3. Filling stitches.

Six rows of half cross stitch to turn inside, worked in dark mauve. Work stitches away from the long-legged cross stitches below. Leave one thread bare at each end of the rows to make it easier to turn this area in.

Mark two canvas threads for one row of long-legged cross stitch, worked in dark mauve.

Mark two canvas threads for one row of long-legged cross stitch, worked in dark mauve.

Mark six canvas threads for three rows of long-legged cross stitch, worked in dark mauve. This area will be the side-edging when the spectacles case is folded.

Eighty-four threads down.

Mark four canvas threads for two rows of long-legged cross stitch, worked in dark mauve.



Two rows of rice stitch, worked in light turquoise and fuchsia. The first and last stitches must use the same holes as the edging stitches.

One row of single-trammed gobelin stitch, worked in dark turquoise.

Two rows of Hungarian diamonds stitch, worked in yellow with light turquoise compensation stitches.

One row of single-trammed gobelin stitch, worked in dark turquoise.

Florentine stitch using yellow, dark turquoise, fuchsia and light turquoise over four threads, rising and falling by two threads each stitch.

Place the bottom of the first fuchsia stitch of this section fourteen threads below the dark turquoise single-trammed gobelin row.

Work down in the colours as shown and fill in compensation stitches at the top in the appropriate colour when the lower part is completed.

Thirty-six threads across.

One row of single-trammed gobelin stitch, worked in fuchsia.

Two rows of Hungarian diamonds stitch, worked in light turquoise with yellow compensation stitches.

One row of single-trammed gobelin stitch, worked in fuchsia.

Two rows of rice stitch worked in dark turquoise and yellow.

Right column:

One row of long stitch, worked over seven threads in light turquoise and fuchsia.

Two rows of single brick stitch, worked in yellow.

One row of single-trammed gobelin stitch, worked in dark turquoise.

Two rows of Parisian stitch, worked in light turquoise with yellow compensation stitches.

One row of single-trammed gobelin stitch, worked in fuchsia.

Work double twill stitch over four and two horizontal threads. Colours as picture (see page 74)

Start stitching about 1.5cm (½in) from the right-hand top edge with a stitch over four threads. Fill in the compensation stitches before continuing down the row.

Fill in the top right-hand corner when the rest of the area is complete.

Thirty-six threads across.

One row of single-trammed gobelin stitch, worked in fuchsia.

Two rows of Parisian stitch, worked in yellow with dark turquoise compensation stitches and four French knots.

One row of single-trammed gobelin stitch, worked in light turquoise.

Two rows of single brick stitch, worked in fuchsia.

One row of long stitch, worked over seven threads in dark turquoise and yellow.

Mark two canvas threads for one row of long-legged cross stitch, worked in dark mauve.

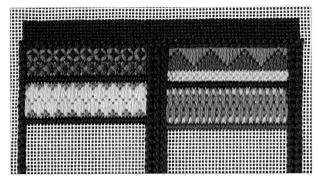

2. Following the instructions on the chart, work the border using dark mauve thread. Start each row with a cross stitch which you then work over, to avoid having some of the canvas showing through. Stitch each row of the upright and horizontal rows in the same direction to ensure all look alike. Once this is complete, stitch the six rows of half cross stitch at the top, then fill in the two top sections of the case as shown on the chart.

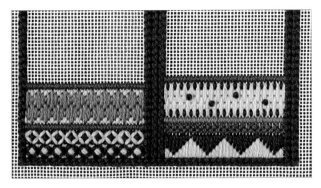

3. Now stitch the two bottom sections, following the instructions on the chart.

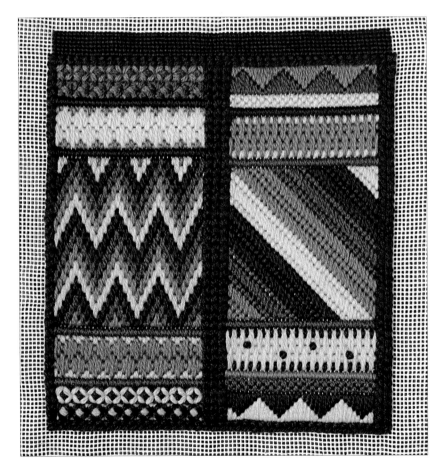

4. Complete the spectacles case by working the middle sections shown on the chart. The Florentine stitches used are illustrated on page 34. Finish by following the instructions on page 16–17 for applying wallpaper paste to the back of the work.

5. When dry, dab a spot of PVA glue into each corner of the frame, and allow to dry.

74

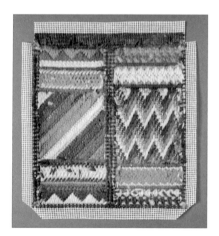

6. Cut the bottom corners of the canvas off at a diagonal, and trim closely to the top corners.

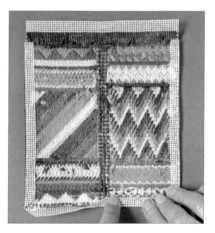

7. Apply PVA glue to the canvas edges of the sides and bottom on the back of the work. Fold the exposed canvas in and stick down.

8. Apply PVA glue to the back of the work and stick the piece of felt on to it. Allow the glue to dry completely.

9. Use the mauve felt tip to colour the exposed canvas at the top. Once dry, apply PVA glue to the back of the half cross stitch section and also to the coloured canvas at the top. Stick both firmly down on to the back of the work over the felt. Hold until completely dry.

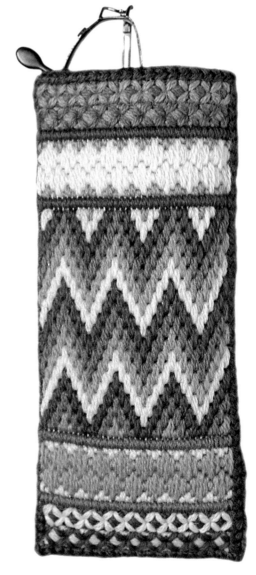

10. Finally, fold the spectacles case in half and oversew the side and bottom with dark mauve wool.

Landscape

This is an imaginary landscape but is based on a hill near my home which has a distinctive group of trees on top. It is an easy project as the field and tree shapes do not have to be exactly like the ones I have stitched, and you can mix the colours differently if you wish, so that the design becomes very much your own. The stitches will not distort the canvas, so it will be very easy to stretch and finish.

The landscape may be framed or used as a cushion centre. If you are making your work into a cushion, it is best to spray it with a fabric protector (see page 17). Finally, one quarter hank of each main colour should be plenty of wool. Very little off-white wool is needed and even less brown.

The hill near my home, which provided the inspiration for the project.

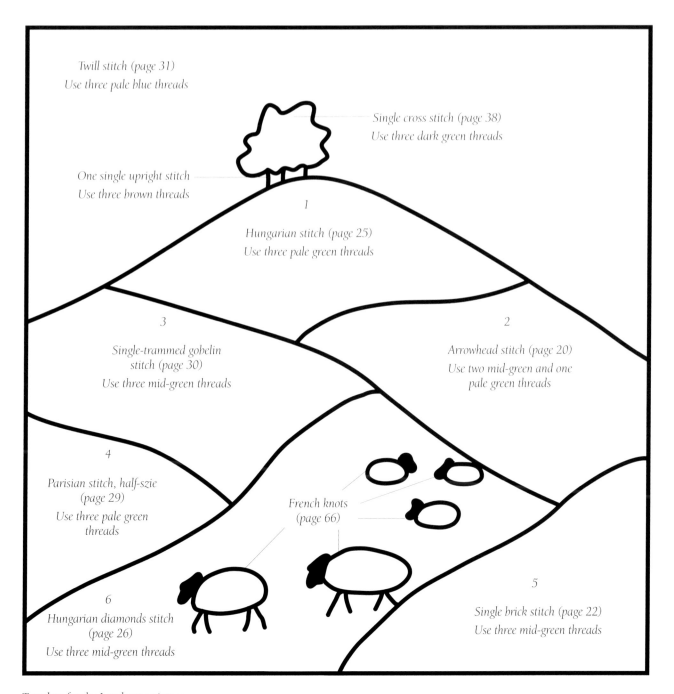

Twill stitch (page 31)
Use three pale blue threads

Single cross stitch (page 38)
Use three dark green threads

One single upright stitch
Use three brown threads

1

Hungarian stitch (page 25)
Use three pale green threads

3

Single-trammed gobelin
stitch (page 30)
Use three mid-green threads

2

Arrowhead stitch (page 20)
Use two mid-green and one
pale green threads

4

Parisian stitch, half-szie
(page 29)
Use three pale green
threads

French knots
(page 66)

6

Hungarian diamonds stitch
(page 26)
Use three mid-green threads

5

Single brick stitch (page 22)
Use three mid-green threads

Template for the Landscape picture.

Method

1. Bind the canvas edges with masking tape and mark the top. Place your prepared canvas over the design. Trace the outlines of the template lightly on to the canvas using a pencil. Each side of the square frame for the picture should be a multiple of two canvas threads so that the long-legged cross stitches fit in exactly.

2. Work a row of long-legged cross stitch along each edge of the marked outside square to frame your picture using two strands of mid dusty pink and one strand of pale dusty pink.

Tip

If your wool becomes thin and shredded, change to a new length as you want the stitches to look chunky and uniform.

3. Work the first five fields in order with the colour combinations indicated on the chart, using compensation stitches to ensure smooth edges as far as possible.

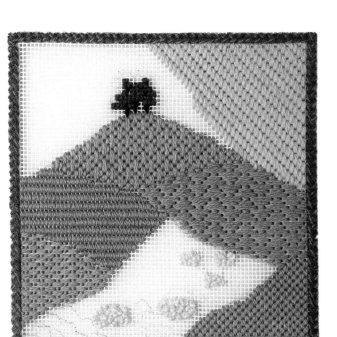

4. The trees must be worked before the sky around them. The trunks are worked first in short straight stitches (dark brown), followed by the foliage in single cross stitches (dark green) to fill the area shown.

5. Work the bodies of the sheep and lambs in French knots (off-white) before stitching the final field.

6. Add the heads to the sheep using small straight stitches in dark brown once the Hungarian diamonds background is in place. The hedges are fairly randomly placed French knots in various mixtures of the two darker greens. The bushes and flowers (pinks and dark green) are French knots placed randomly in the lower part of the picture.

5. When the stitching is completed, stretch your picture as explained in the finishing instructions (see pages 16–17).

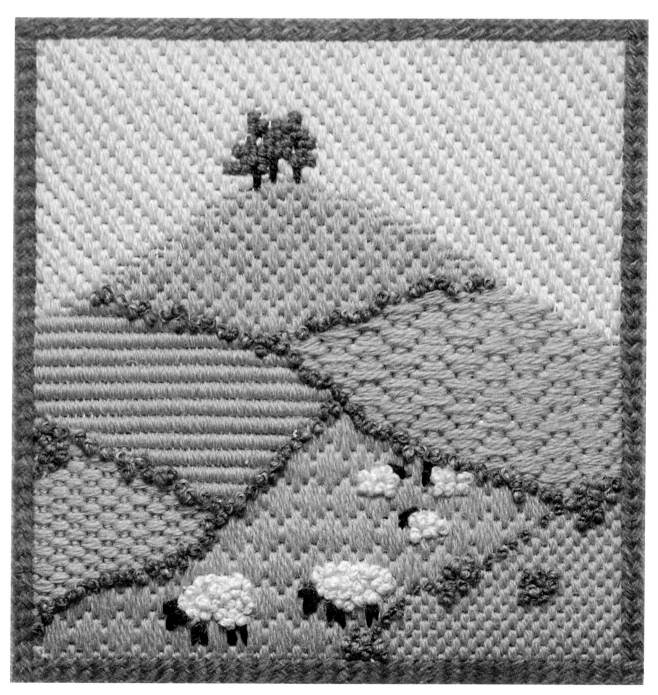

The finished landscape.

Index